THEN *&* NOW

LEXINGTON

OPPOSITE: Thoroughbreds are taken on a riding lesson at Hamburg Farm. (Courtesy of the Lexington History Museum.)

THEN *&* NOW

LEXINGTON

Fiona Young-Brown

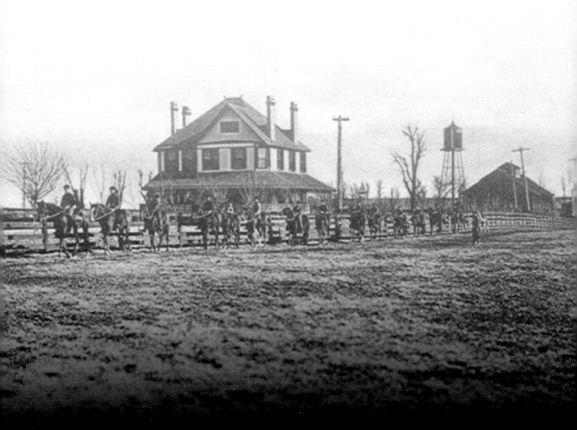

For Nic, my love and my constant support. You are my sunshine.

Copyright © 2008 by Fiona Young-Brown
ISBN 978-0-7385-5447-1

Library of Congress control number: 2008925860

Published by Arcadia Publishing
Charleston SC, Chicago IL, Portsmouth NH, San Francisco CA

Printed in the United States of America

For all general information contact Arcadia Publishing at:
Telephone 843-853-2070
Fax 843-853-0044
E-mail sales@arcadiapublishing.com
For customer service and orders:
Toll-Free 1-888-313-2665

Visit us on the Internet at www.arcadiapublishing.com

ON THE FRONT COVER: The changes on Main Street are evident, but some reminders of the past remain. (Courtesy of Lexington History Museum.)

ON THE BACK COVER: Children wander along Short Street in downtown Lexington in 1898. (Courtesy of Art Work of the Blue Grass Region of Kentucky, Special Collections and Digital Programs, University of Kentucky.)

CONTENTS

ACKNOWLEDGMENTS

This book would not have been possible without the help of so many people. Jason Flahardy at the University of Kentucky Special Collections Department provided invaluable help with the photographic collections. Jan Marshall and the staff at the Lexington Public Library were of great assistance, as was Eric Brooks, the curator of the Ashland Estate. Thanks are also due to Jamie Millard at the Lexington History Museum and Ann Mason of the National Parks Service. Sarah Katzenmaier generously allowed me to use images from the Barton K. Bataille Collection—I hope I am able to do them justice. I am also enormously indebted to B. J. Gooch at Transylvania University for allowing me to access the Bullock and Coleman Collections. Foster Ockerman came forward at the 11th hour, providing the most wonderful assistance with locating an old church—I am truly grateful. Thank you to Luke Cunningham of Arcadia Publishing for his support in getting this project off the ground and to my niece Nikita for her excitement that "Auntie Fi" is writing a book. Finally, I am forever thankful to my husband, Nic, who believes in me more than I could imagine.

All "now" images were taken by the author.

INTRODUCTION

Since moving here seven years ago, I am proud to say that Lexington has become my new home. Surrounded by farms and greenery that remind me of my native England, I have become enchanted by the Bluegrass as I have explored my Kentucky husband's heritage.

From the moment I first relocated here, I was intrigued by a mysterious one-room building that seemed to have been deserted decades ago. I would later learn the history of Cadentown School and its importance in the former black hamlet of the same name, which has now been swallowed up by urban growth. As I explored the broken gravestones that lay behind the former church and school, I was reminded of what we risk losing in our modern rush for development. Fortunately, the school has now undergone an extensive restoration project and will hopefully become a museum to remind Lexingtonians of the city's African American history. In the meantime, while many other buildings were lost to the ravages of time, the seeds for a book such as this were planted.

Lexington has historically been the center of economic and cultural life for Kentucky. Notably, the city did not grow up around a major waterway; instead it developed a thriving commercial and agricultural heritage because of its central location within the state.

The first university west of the Alleghenies, Transylvania University, was established here in 1780 and housed a medical school, law school, and seminary. The presence of this university helped to establish Lexington as an educational center for Kentucky, the "Athens of the West." As such, it is now also home to the University of Kentucky (one of the state's largest employers) and several other college campuses.

Lexington was the site for several pioneering schools for African Americans, including the aforementioned Cadentown. Indeed the African American community in Lexington holds a strong presence that has long been overlooked but is now the subject of historic renovation. Several key black neighborhoods have undergone face-lifts in recent years, and local groups are hoping to raise enough money to return the Lyric Theater, which once played host to such greats as Louis Armstrong and Ella Fitzgerald, to its former glory. The First African Baptist Church is the third oldest black Baptist congregation in the United States.

For more than 200 years, horse racing has been a vital part of local life, providing both economic and social indulgences. Although today only two tracks remain (Keeneland and the Red Mile), numerous other tracks are known to have existed before Keeneland's opening in 1936. Joseph Bryan, owner of the Waveland estate, held regular meets at the track on his property in the 1850s. Meanwhile, on the other side of town, the Hamburg Farm offered an equally impressive racetrack.

Statesman and horseman Henry Clay had his home and his law practice within the downtown area. Today a monument to him towers above the other graves at the Lexington Cemetery. An equally famous resident of the city was Mary Todd, the wife of Abraham Lincoln. The Todd Lincoln House is now open to the public as a museum and was the first historic site to be dedicated to a first lady.

Development and growth have been mixed blessings for Lexington, now the crossroads of two major interstate highways. In the past 10 years, many thousands of acres of historical farmland have been lost to commercial development. The ever-growing Beaumont and Hamburg districts are perfect examples of once-rural communities that have been swallowed up by shopping malls and housing subdivisions. The farms for which Fayette County is famous have now all but disappeared, and only a few visible signs remain of the region's once great equestrian heritage. One of the most debated issues today is the protection of the remaining Bluegrass.

As I gaze across the fields of Keeneland, enjoying the spring meet, it is my hope that while we look to the future, we do not forget to celebrate and protect our past.

CHAPTER 1

GOVERNMENT AND DOWNTOWN

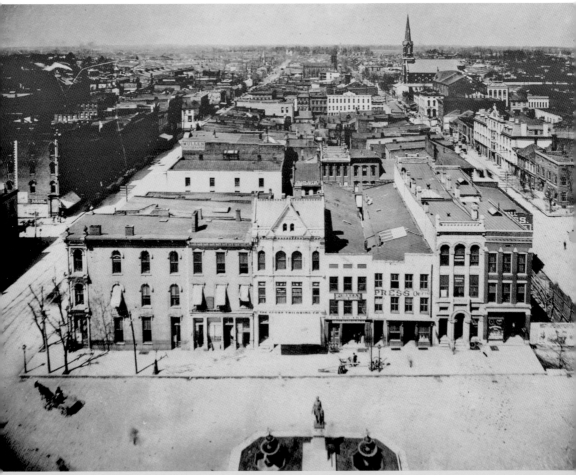

In this image, taken from atop the courthouse shortly before the beginning of the 20th century, one has a clear view of the downtown area. Immediately in front of the courthouse are Cheapside and the statue of John C. Breckinridge, while in the distance the Henry Clay monument in the Lexington Cemetery is visible. (Courtesy of the Bullock Photographic Collection, Transylvania University.)

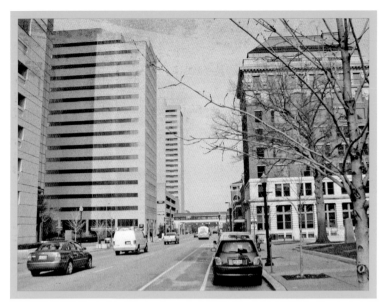

Main Street has changed a great deal during the past 100 years, although some familiar structures remain, particularly the courthouse and the former Lexington City National Bank Building, as seen here on the right. To the left now stand a number of high-rise office buildings and hotels. The tramlines are long gone. Notice the covered pedestrian walkway that links buildings on either side. (Courtesy of the Lexington History Museum.)

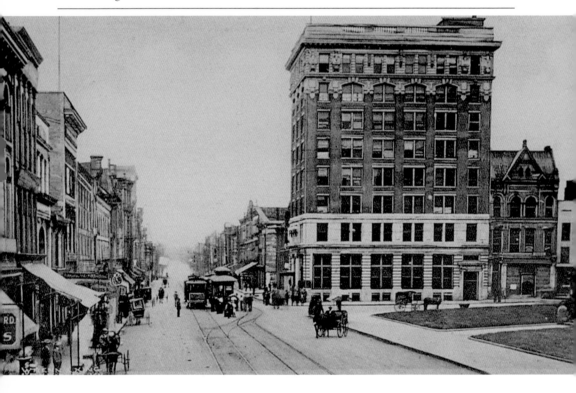

GOVERNMENT AND DOWNTOWN

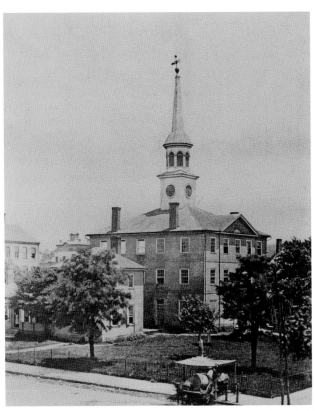

This incarnation of the Fayette County Courthouse stood from 1806 until 1883. Two more have stood on the same spot since then. In 2001, a new Courthouse Square was constructed several blocks away, and the building shown now houses several small museums, including the Lexington History Museum. Note the man in the foreground of the photograph. He is gathering water from a well in order to sprinkle the dusty city streets. (Courtesy of the Bullock Photographic Collection, Transylvania University.)

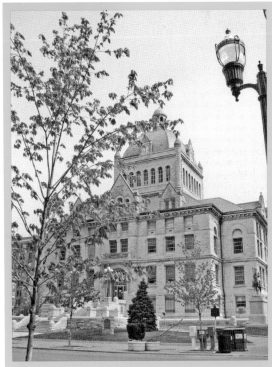

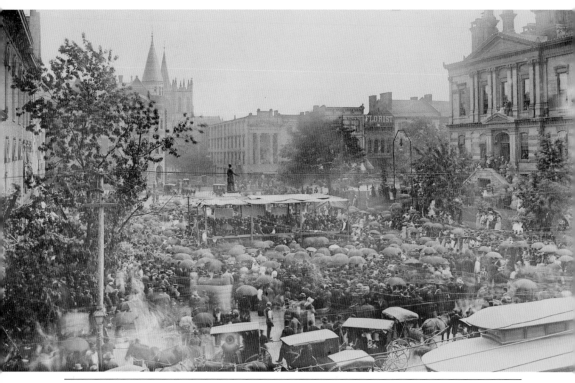

Kentucky's centennial coincided with the Columbus quadricentennial in 1892. Crowds of revelers are seen here along Cheapside, no doubt to view the presentation of the paintings that were a gift from the city of Philadelphia. Cheapside was once the largest slave-trading district in the state, and after the Civil War, the locality remained the site of monthly court days until 1921. Today the markets may be gone, but business space and restaurants remain. (Courtesy of the collection of Barton K. Bataille.)

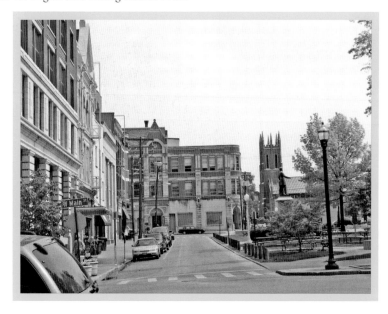

GOVERNMENT AND DOWNTOWN

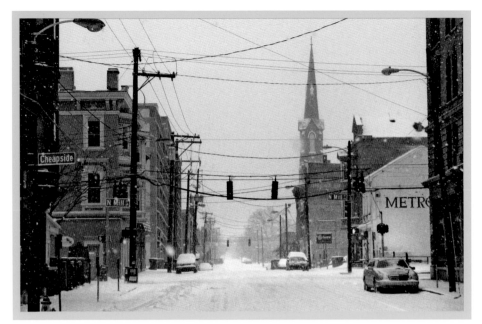

Compared to the large number of obvious visual changes on Main Street, this section of Short Street has changed relatively little during the past 100 years. Notice the spire of St. Paul Catholic Church and Metropol, the city's oldest surviving post office building, which is now a restaurant. Just a few blocks away, one can see significant changes, with the loss of hotels and the addition of a museum and an opera house. (Courtesy of Art Work of the Blue Grass Region of Kentucky, Special Collections and Digital Programs, University of Kentucky.)

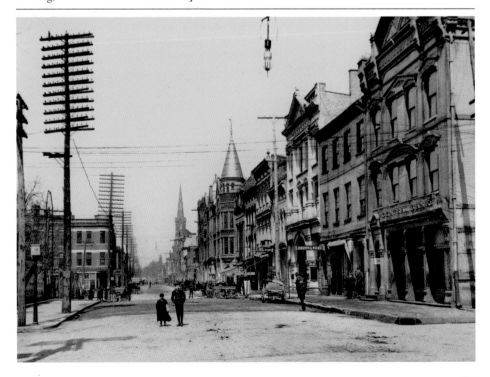

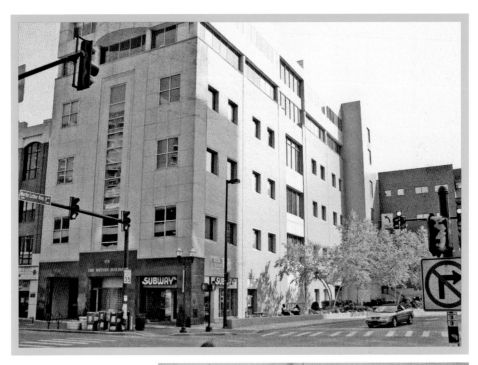

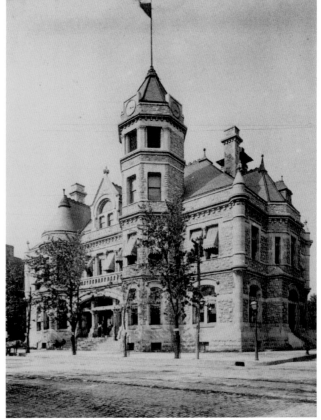

The magnificent post office that used to stand on the corner of Main Street and Walnut Street and faced Union Station was given the nickname "the Dream of Stone" during its construction. Used as a post office until 1934, the Old Federal Building was later a Lowenthal's store until it was torn down in 1941. A Subway restaurant now stands on the corner. (Courtesy of the collection of Barton K. Bataille.)

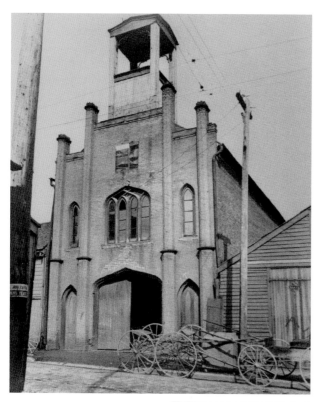

Although a strange idea now, at one time in its history the city of Lexington had three different fire companies, one of which, the Lyon Fire Company on South Limestone, is shown here. After two major fires swept through downtown in 1871, the city decided to consolidate the fire companies into one. The Lyon Fire House was sold, and a central station was established. Today a bank stands on the spot. (Courtesy of the collection of Barton K. Bataille.)

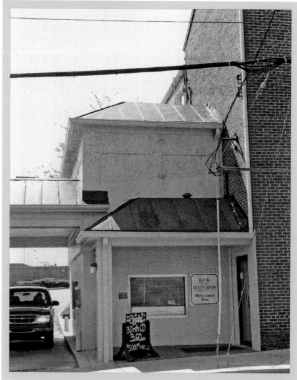

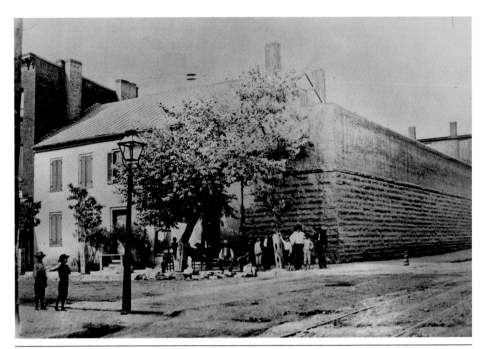

The brick county jail built on the corner of Limestone and Short Street following multiple fires and escapes from the previous wooden structure soon came to be named after jailer Thomas Megowan. In this *c.* 1885 photograph, a crowd of men have gathered outside Megowan's, which also housed runaway slaves until they could be returned to their owners. It was later the site of Merrick Hall, which burned down in 1917. Until recently, a restaurant stood here. (Courtesy of the J. Winston Coleman Jr. Photographic Collection, Transylvania University Library.)

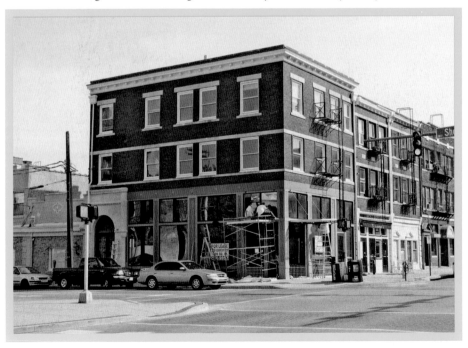

GOVERNMENT AND DOWNTOWN

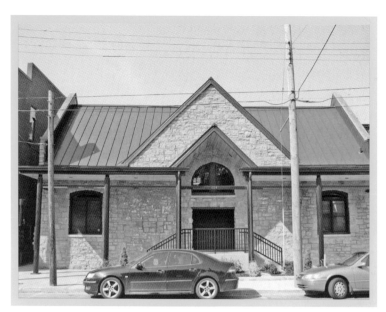

One of the more notorious locations in Lexington's history is Robards's Slave Hall on Short Street. Lewis Robards was a notorious slave trader who was accused of abducting free slaves so he could sell them. He had a reputation for concealing illness in a slave long enough to make the deal, and he kept a select group of mulatto women upstairs for his own use. A small African American church was later built on the spot, and today it is privately owned. (Courtesy of the collection of Barton K. Bataille.)

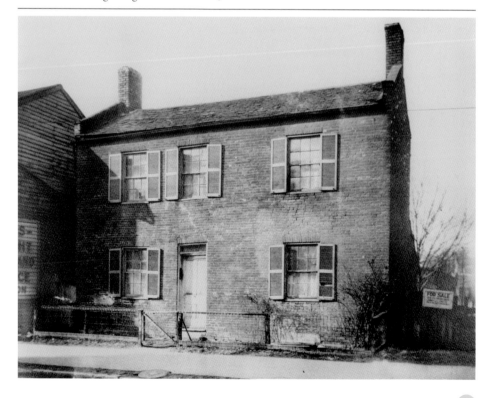

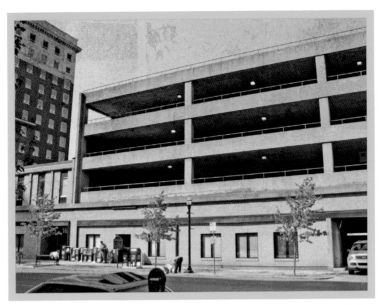

In these days of automobiles and airplanes, it is easy to forget that rail travel was once widely used. The Union Station that once stood on Lexington's Main Street offered passenger services on both the Louisville and Nashville Railroad and the Chesapeake and Ohio Railway. The station opened in 1907 and was razed in 1960. The last passenger train left Lexington from another station in 1971. Many of downtown's historic buildings have been demolished to create parking space, and Union Station was no exception. (Courtesy of the Lexington History Museum.)

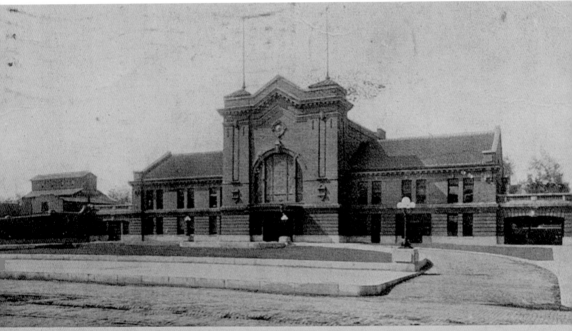

Union Station, Lexington, Ky.
Photo by Thos. A. Knight.

GOVERNMENT AND DOWNTOWN

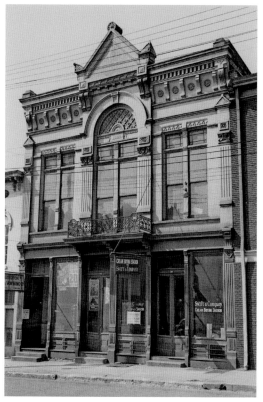

Lell's Hall, located on West Short Street, was one of the more lively entertainment establishments in Lexington at the beginning of the 20th century. Built in 1882, it offered a beer parlor on the first floor and a theater on the second. The theater tended toward the burlesque variety, and Lell's was certainly not a place where most respectable women would be seen. The building is still used as a bar. (Courtesy of the J. Winston Coleman Jr. Photographic Collection, Transylvania University Library.)

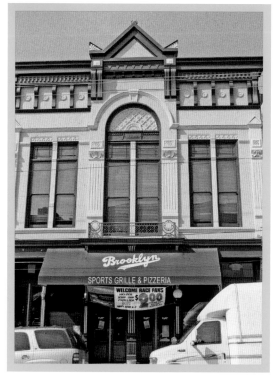

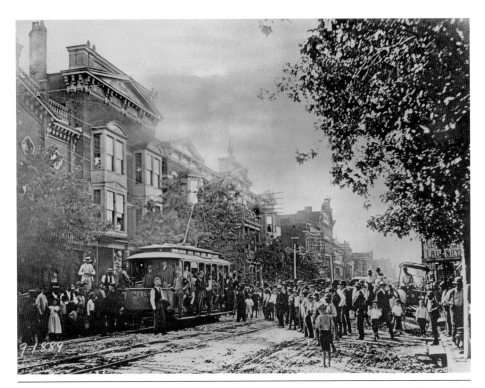

This 1889 image shows the city's first streetcar outside the Phoenix Hotel. The hotel, originally Postlethwaite's Tavern, became the Phoenix in the 1820s. At various times during the Civil War, the hotel served as the headquarters for both Union and Confederate generals. It remained a well-known local landmark until its demolition in the 1980s. When the planned redevelopment of the site failed to happen, the site was dedicated as Central Park and later was renamed Phoenix Park. (Courtesy of the Lexington Public Library.)

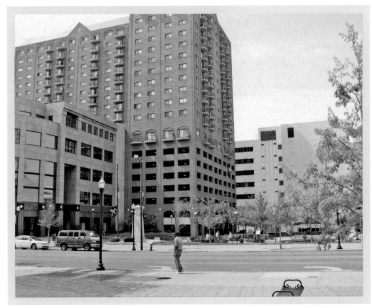

GOVERNMENT AND DOWNTOWN

CHAPTER 2

TRADE AND COMMERCE

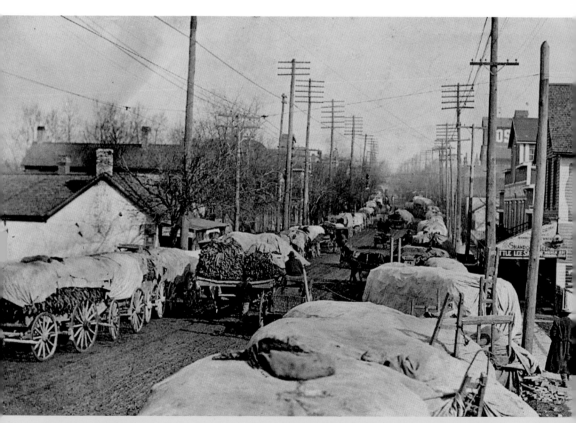

Since its early days, Lexington has been a central point for commerce within Kentucky. Banking, trade, and agriculture came together in this growing city. Following the Civil War era, as cigarettes became more popular among soldiers, tobacco farming became a major industry in the state. Here the carts gather for the sales. (Courtesy of the Lexington History Museum.)

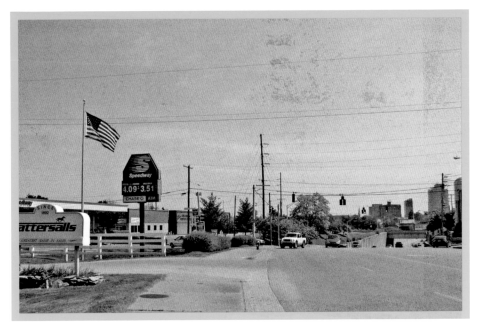

In this image, carts piled high with the all-important tobacco harvest are seen lining Broadway waiting to be sold at the Lexington burley markets, which by the 1900s were the world's largest. Broadway remains a busy thoroughfare into downtown Lexington, albeit without the tobacco carts, and Tattersall's is still in business, now as one of the premiere Saddlebred sales companies. (Courtesy of Selected Images of Lexington [1930–1950], University of Kentucky Libraries.)

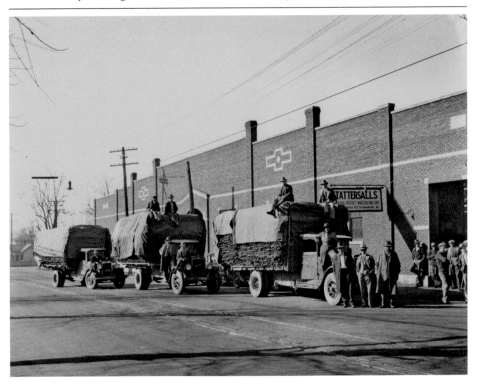

TRADE AND COMMERCE

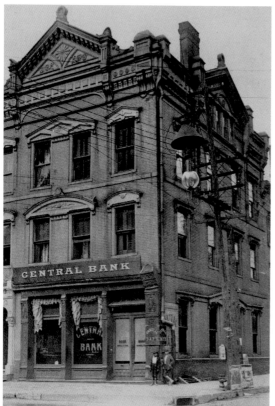

The Central Bank building, shown here, was apparently home to a Girl Scout troop at one point in its history. Like so many other buildings in the downtown area, it was demolished in 1924, and the bank has now moved its main branch and headquarters to another location. However, an equally impressive (and taller) building now stands in its place, providing office space for a number of legal firms. (Courtesy of the Bullock Photographic Collection, Transylvania University.)

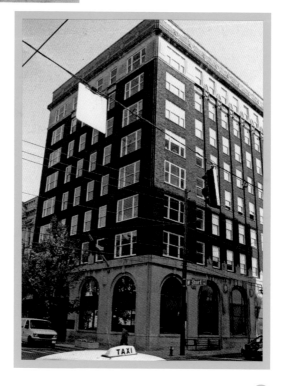

Sayre's Bank, established in 1823 by David A. Sayre, the founder of the Sayre Female Institute, stood on the corner of Short and Mill Streets. The building had previously been the home of John Pope, an attorney and political rival of Henry Clay. The bank was the oldest in Lexington when it went out of business in 1899, following the death of its president. The Security Trust Company now stands on the site. (Courtesy of the Bullock Photographic Collection, Transylvania University.)

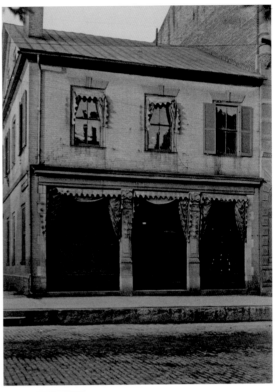

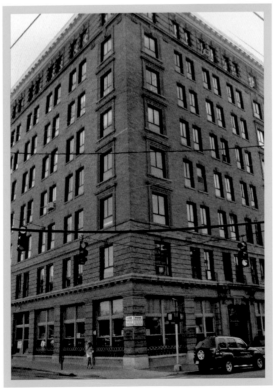

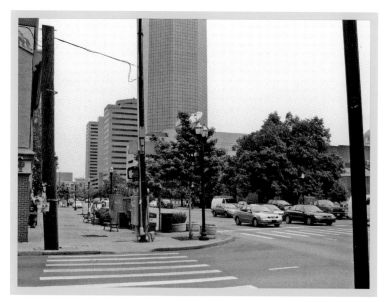

Jackson Hall, home of the city market, was built in 1879 and stretched for an entire city block between Limestone and Upper Street. The massive two-story building also housed a clothing manufacturer upstairs. In 1941, the building was demolished, and the site became a parking lot. However, with the urban redevelopment of the 1960s, Vine and Water Streets merged, and one would never guess that a building of such size stood where the road now runs. (Courtesy of Selected Images of Lexington [1930–1950] University of Kentucky Libraries.)

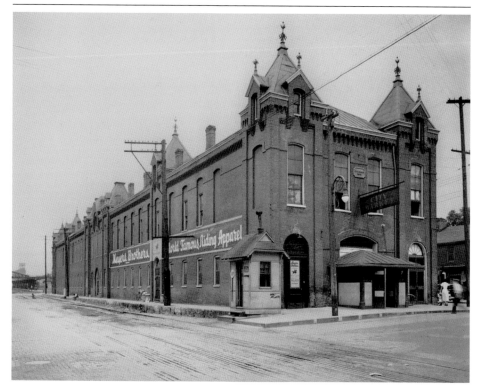

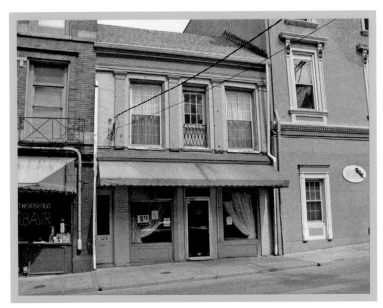

Giron's Confectioners on Mill Street was a favorite of Mary Todd Lincoln in her youth. The recipe for Lincoln's almond cake is actually a recipe created by the Frenchman Mathurin Giron. It is said that the Todd family loved the cake so much that it became a family tradition. The upstairs was a dance hall and the scene of many a cotillion during the first half of the 19th century. In 1838, a saloon was added that served cakes and ice creams. (Courtesy of the Bullock Photographic Collection, Transylvania University.)

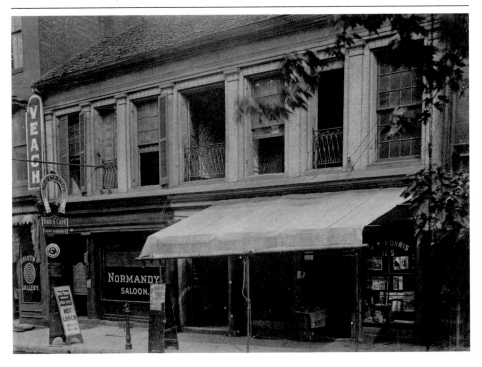

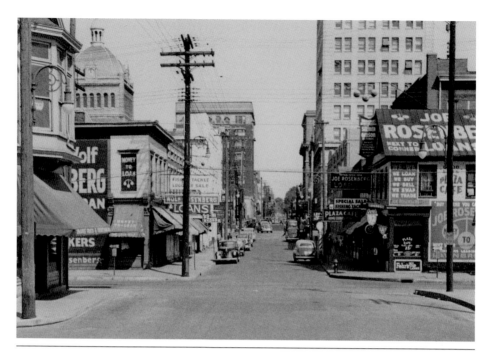

Joe Rosenberg Jewelers is one of the oldest businesses still in operation in downtown Lexington. Opened in 1896 by a Lithuanian immigrant, the store sells jewelry and has a pawn business. Passed down through the family, Rosenberg's has remained in the same location for more than 100 years. Unfortunately, it and all of the other buildings in the same block were scheduled to be demolished in 2008. Controversial plans to replace them with a high-rise office block are in development. (Courtesy of the J. Winston Coleman Jr. Photographic Collection, Transylvania University Library.)

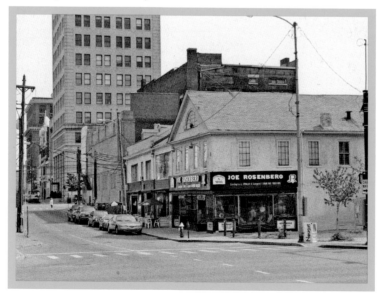

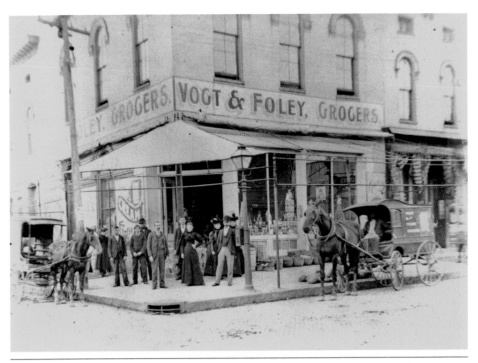

The northwest corner of Broadway and Short Street was the site of one of Lexington's first post offices. Later the building was used as a grocery store, which was owned by Henry Vogt and a Mr. Foley in this image from 1870. The corner continued to be the site of a grocery store and was later a Kroger. In the 1970s, the Lexington Opera House underwent extensive renovation to save it from demolition, and the opera house now extends to the corner of Broadway and Short Street. (Courtesy of the collection of Barton K. Bataille.)

TRADE AND COMMERCE

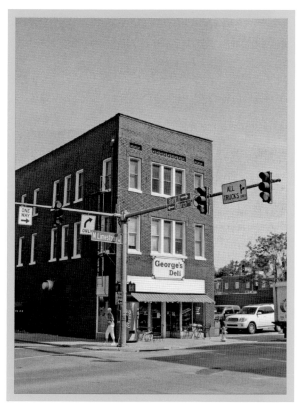

The 1818 *Lexington Business Directory* lists a John Norton as the owner of a drugstore on Main Street, and the 1838 directory lists a druggist named George W. Norton. Norton's Drug Shop is shown here. Until recently, there were two remaining pharmacies downtown: Hutchinson's and a RiteAid. Sadly, both have now closed their doors. Meanwhile, a deli and sandwich shop stands on the former Norton's site at the corner of Limestone and Church Street. (Courtesy of the Bullock Photographic Collection, Transylvania University.)

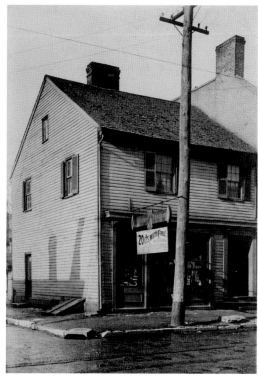

Wilson and Stark's clothiers stood on the south side of Main Street between Lime and Upper Streets. After being bought out by Len Cox and George Graves, the business became Graves, Cox and Company in 1888—still a men's clothing store. The family-owned business remains a feature of Lexington's downtown, now on premises elsewhere along Main Street. The building shown here was demolished in 1996 after sitting vacant for 14 years and is now a parking lot. (Courtesy of the J. Winston Coleman Jr. Photographic Collection, Transylvania University Library.)

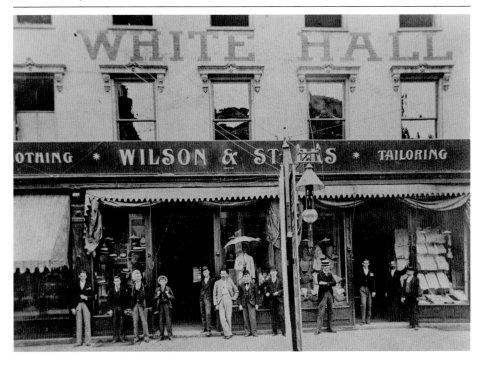

TRADE AND COMMERCE

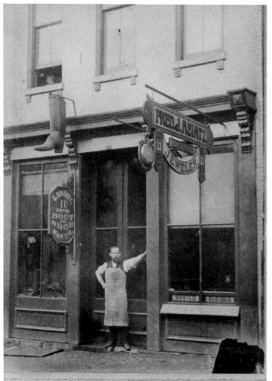

In this 1884 photograph, George Strobel, a custom boot and shoemaker, stands in the doorway of his store on Limestone. Notice the jewelry store owned by Fred Heintz next door. The block has undergone quite a few changes in the past 120 years, and it would be hard to recognize where either of these stores once stood. The same location is now a nightclub. (Courtesy of the J. Winston Coleman Jr. Photographic Collection, Transylvania University Library.)

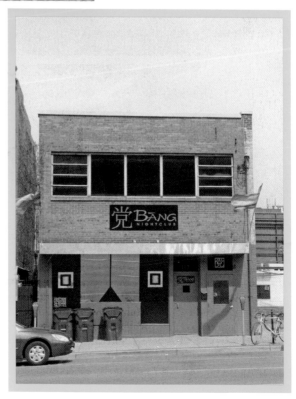

The *Lexington Herald* started life as the *Lexington Daily Press* in 1870. It eventually became the *Morning Herald* in 1905. In 1937, the owner of the competing *Lexington Leader* bought the *Herald*, and both papers ran concurrently until 1983—the *Herald* in the morning and the *Leader* in the afternoon. In 1980, the newspaper moved its production to a new facility. This National Register of Historic Places–listed building at the corner of Short and Walnut Streets is now a series of luxury loft apartments. (Courtesy of the collection of Barton K. Bataille.)

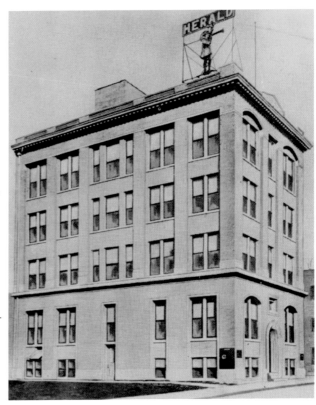

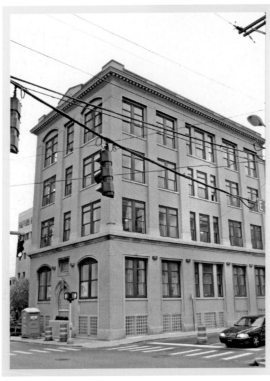

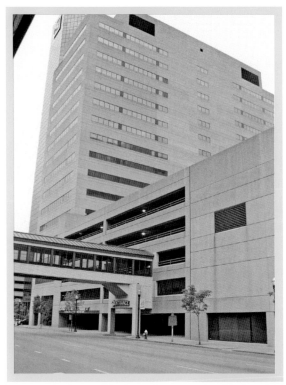

Here is the store of J. B. Wilgus and Company in the 1890s. John Wilgus was a local businessman, grocer, and banker, as well as the original owner of Parker Place—the house where Mary Todd Lincoln was born. In the 1940s, this was the site of the J. D. Purcell clothing store. Main Street has changed a great deal, and the entire block is now part of a hotel and parking complex. (Courtesy of the J. Winston Coleman Jr. Photographic Collection, Transylvania University Library.)

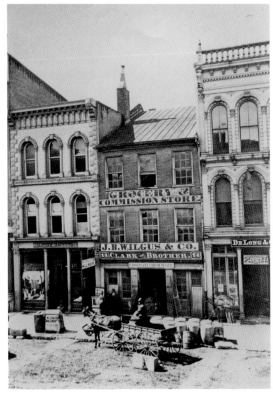

This building, which was constructed in 1870, was originally known as the Ashland House. It later became known as the Reed Hotel and stood next to the Palace Hotel on the north side of Short Street between Broadway and Mill Street. Later it changed names again to become the Drake Hotel. In 1962, the building was torn down, and the space was turned into a parking lot. (Courtesy of the Lexington Public Library.)

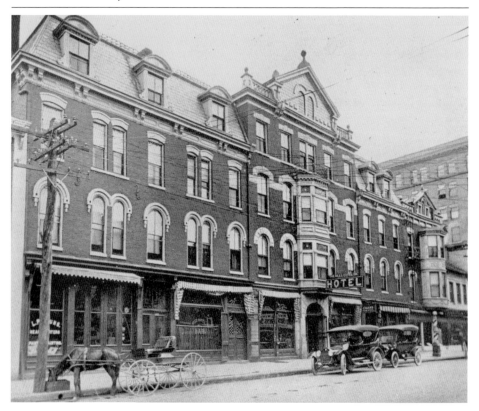

TRADE AND COMMERCE

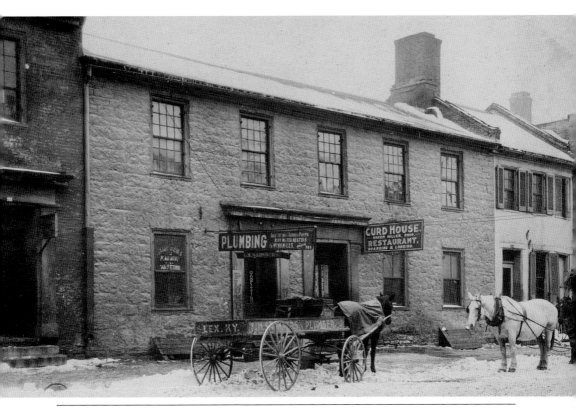

Situated between a livery stable and a mustard factory, the Curd House—built in 1829—was one of Lexington's most celebrated taverns. The property was originally a woolen factory owned by Richard Curd. After Curd's death, it was converted into a tavern by a family member. During the extensive redevelopment of Vine and Water Streets in the latter half of the 20th century, the block where the Curd House once stood was completely remodeled. A bank now stands on the site. (Courtesy of the Bullock Photographic Collection, Transylvania University.)

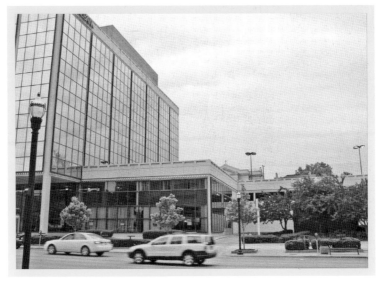

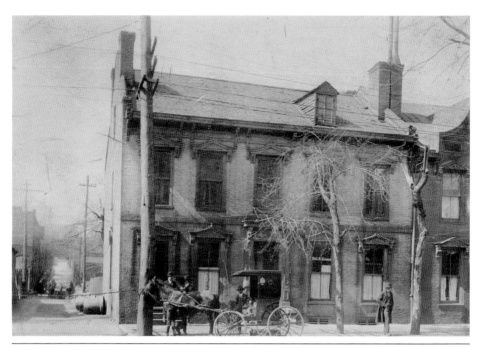

McAlister's Boarding House once stood on the corner of Main Street and Ayers Alley. It is rumored to have once been the residence of Gen. John Moore McCalla, a distinguished veteran of the War of 1812. Over time, the streets downtown have altered significantly. On the corner where the boardinghouse once stood, Union Station was built; it has now been replaced by a parking structure and the Fayette County Clerk's Office. (Courtesy of the Bullock Photographic Collection, Transylvania University.)

TRADE AND COMMERCE

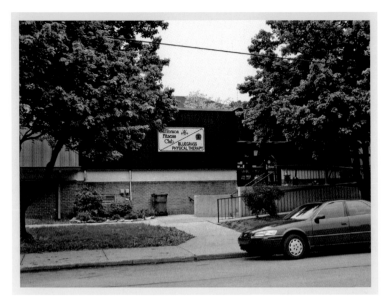

Glendower, on Maryland Avenue, was built around 1815 for the widow Mary Russell. By 1910, it had become the Preston Inn. The property was then sold to John Milward, who used it as a funeral home, which is shown in this 1921 photograph. After Milward's death, the building was sold at auction. Today the Jefferson Fitness Center stands here. (Courtesy of Lexington Photographs, Special Collections and Digital Programs, University of Kentucky.)

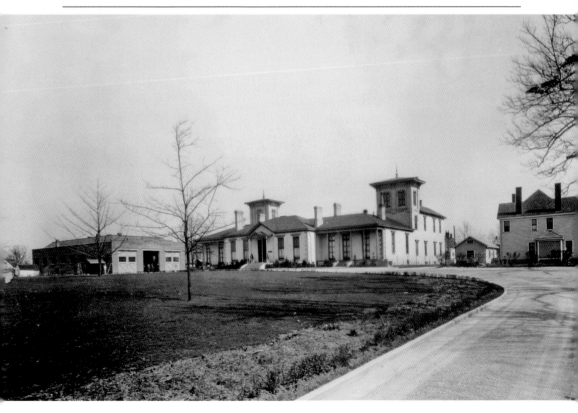

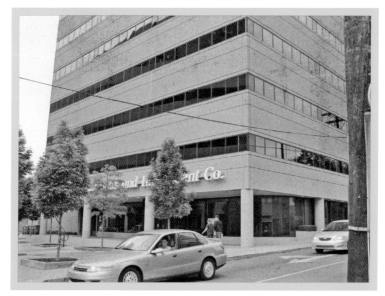

As far back as 1818, an inn stood on this corner of Limestone and Vine Street. Owned by William Geers, the property was sold and was then known as the James O'Mara's Tavern. Years later, it would be the site of Young's Bakery. From the 1960s on, much of Vine Street was part of an enormous redevelopment scheme, and all of the former buildings are long gone, replaced by new office buildings. (Courtesy of the Collection on Lafayette Studios, University of Kentucky Archives.)

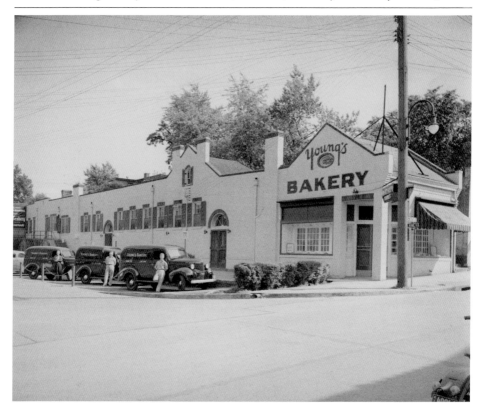

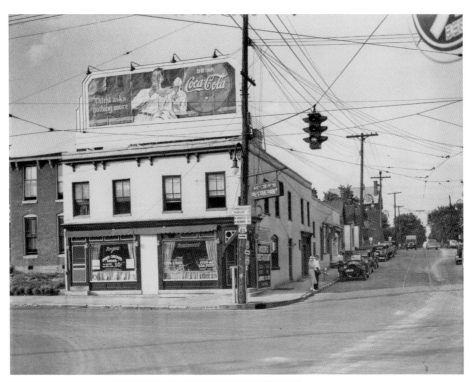

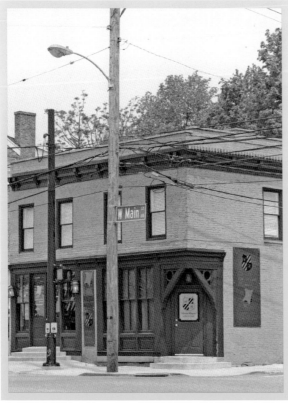

Truly a Lexington dining institution during the 20th century, Rogers Restaurant opened at 601 West Main Street in 1923 in a space previously used as a confectioner's shop. The restaurant was especially popular for its chili and home-style cooking. In 1965, it moved from this location to South Broadway, where it remained until its closure in July 2004. The original location (shown here in 1938) was, until recently, an antique shop. (Courtesy of Selected Images of Lexington [1930–1950], University of Kentucky Libraries.)

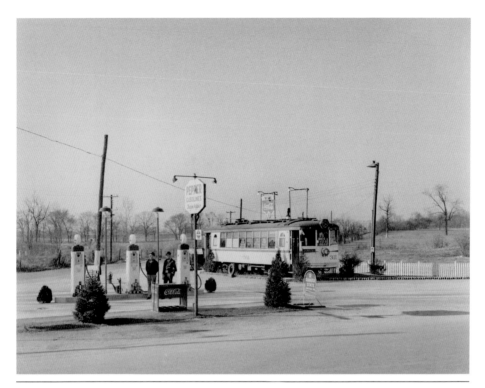

This picture of Earl Carr's filling station on North Broadway shows just how much the structure of Lexington has changed over the years. Back in the 1930s, this was a rural route to Paris. Today it is unrecognizable as a busy intersection, bustling with shops and traffic. Belt Line Avenue, which met with Broadway in the original picture, now ends several blocks before the two ever meet, with residential neighborhoods separating the two. (Courtesy of the Collection on Lafayette Studios, University of Kentucky Archives.)

TRADE AND COMMERCE

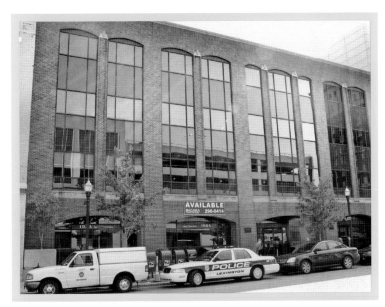

Formerly a livery stable, the 1,600-seat Strand Theater opened opposite Union Station in 1915. It closed 59 years later in 1974 and was demolished in 1979. Incredibly, the projectionist, Bob Erd, worked at the Strand from the day it opened until the day it closed. In 1983, work began on the Lion Office Building, which stands in its place. Notice the lions on the wall of the theater and the statues outside the current building. (Courtesy of the J. Winston Coleman Jr. Photographic Collection, Transylvania University Library.)

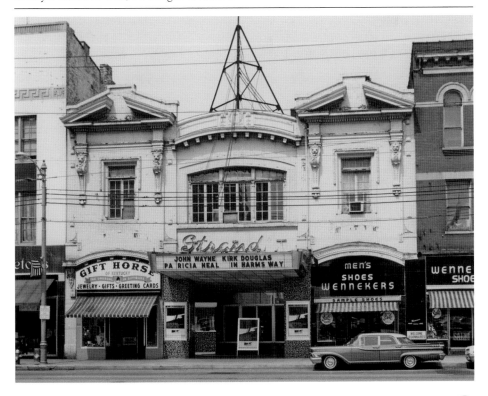

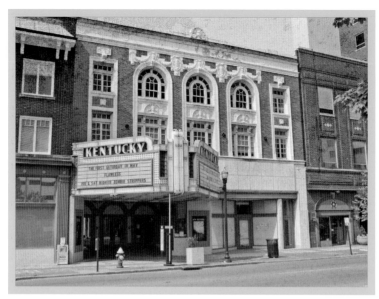

Built in the early 1920s and shown here in 1930, the Kentucky Theater remains a landmark in downtown Lexington. The grand opening took place on October 4, 1922, with a Norma Talmadge romance, *The Eternal Flame*. It was the first theater in Lexington to switch to sound. In the 1980s, the Kentucky introduced the still popular midnight shows. The theater underwent extensive renovation in the early 1990s to repair fire damage and today hosts first-run movies, independents, and classics from years gone by. (Courtesy of Selected Images of Lexington [1930–1950], University of Kentucky Libraries.)

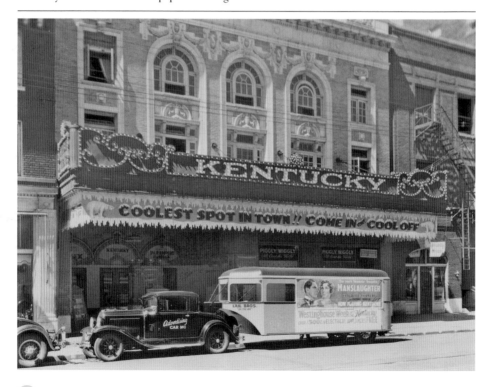

TRADE AND COMMERCE

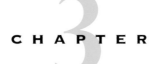

HOMES AND NEIGHBORHOODS

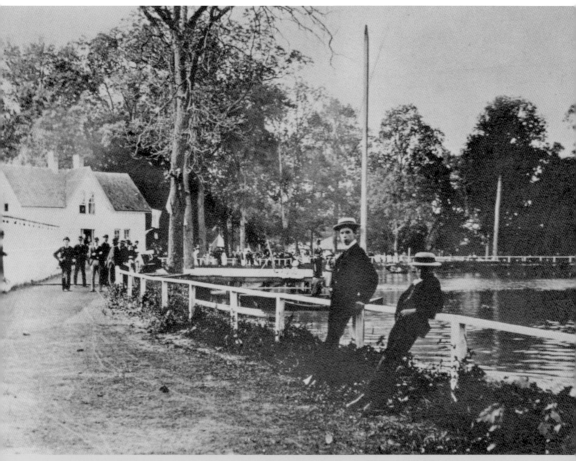

As Lexington has grown far beyond its original boundaries, former estates around the city boundaries have now become a series of charming historic neighborhoods. Woodland Park, located near Henry Clay's Ashland Estate, is a familiar spot with local residents. Pictured is the lake that once attracted visitors at the beginning of the 20th century. One of the young men in the foreground, Sam Lee, went on to become a popular comedian. (Courtesy of the J. Winston Coleman Jr. Photographic Collection, Transylvania University Library.)

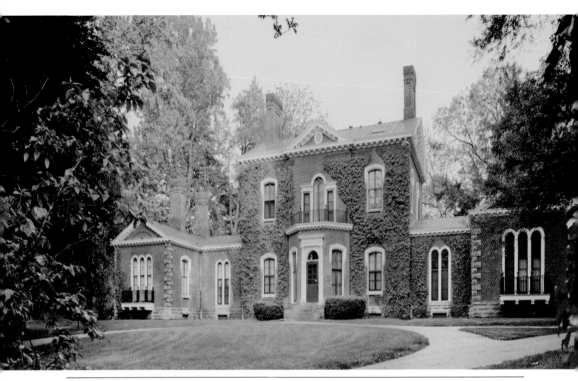

Work began on the magnificent house at the Ashland Estate in 1804; the wings were added a few years later. Statesman and lawyer Henry Clay lived on this 600-acre farming estate for more than 40 years. After his death, Clay's son James rebuilt the entire house in the Italianate style seen today. Although much of the estate was sold off over the years, the house remained in the Clay family until 1948. It is now open to the public. (Courtesy of the Library of Congress, Prints and Photographs Division, Historic American Buildings Survey.)

HOMES AND NEIGHBORHOODS

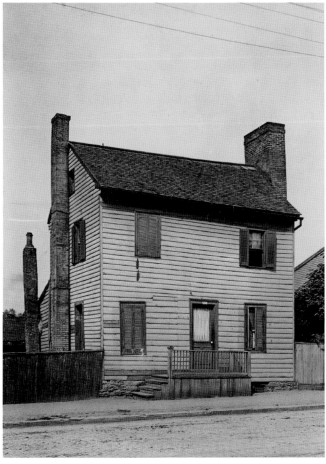

In the 1970s, the University of Kentucky Wildcats found a new home with the construction of Rupp Arena. Coupled with the attached convention center, Rupp plays host to basketball games, concerts, and other large-scale events. The complex also features a hotel, food court, and shopping area. The house seen here is one of those that once stood on Main Street where Rupp Arena now dominates the landscape. (Courtesy of the Bullock Photographic Collection, Transylvania University.)

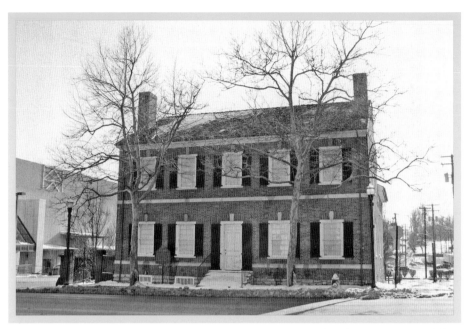

The Mary Todd Lincoln House has been a store, a private home, and a brothel. Standing on what was once the western edge of town, the two-story house was the home of Robert S. Todd and his family in 1832. Mary Todd lived there until she moved to Springfield, Illinois, in 1839. Saved from demolition for the construction of the neighboring Rupp Arena in the 1970s, the house was the first museum in honor of a first lady. (Courtesy of the collection of Barton K. Bataille.)

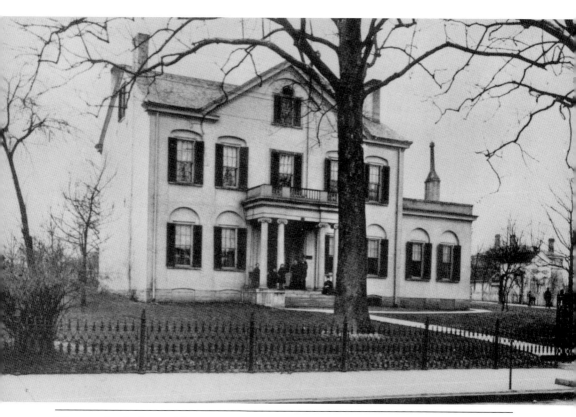

What is today the heart of downtown Lexington was once a residential and commercial district. Seen here is the Swift House, the residence of Dr. William Rodes, pictured in 1898. It was once the home of Dr. Lyman Beecher Todd, a cousin of Mary Todd Lincoln and the postmaster of Lexington during the Civil War. Calvary Baptist Church now stands on the site. (Courtesy of the collection of Barton K. Bataille.)

The Talbert House was built in 1879 for Maria Dudley. It is said that she built it because she wanted a small house after spending her childhood in the much larger Loudoun House. In 1909, the house was passed to Minnie Talbert and then to her son, William. Upon his death in 1966, William's wife sold it to the Bluegrass Trust for Historic Preservation. Today the striking house overlooking Gratz Park is a privately owned residence. (Courtesy of the Library of Congress, Prints and Photographs Division, Historic American Buildings Survey.)

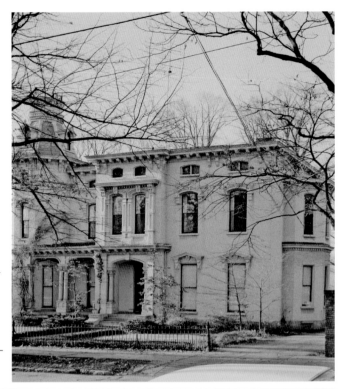

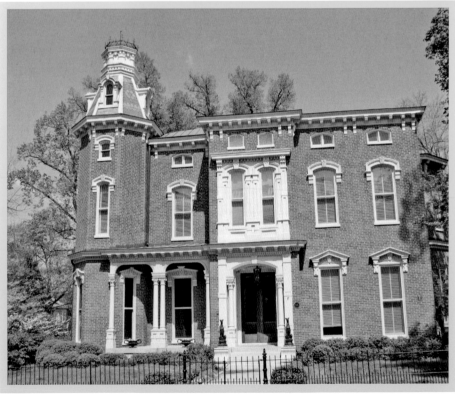

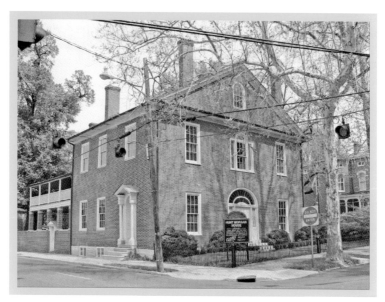

Hopemont, the Hunt-Morgan House, was built between 1811 and 1814 for John Wesley Hunt, the first millionaire in Kentucky. His grandson was Gen. John Hunt Morgan, a Confederate hero in the Civil War. His great grandson Dr. Thomas Hunt Morgan, is the only Kentuckian to have won a Nobel Prize. In 1955, the house was saved from demolition by what is now the Bluegrass Trust for Historic Preservation. It is also home to the Alexander T. Hunt Civil War Museum. (Courtesy of the Art Work of the Blue Grass Region of Kentucky, Special Collections and Digital Programs, University of Kentucky.)

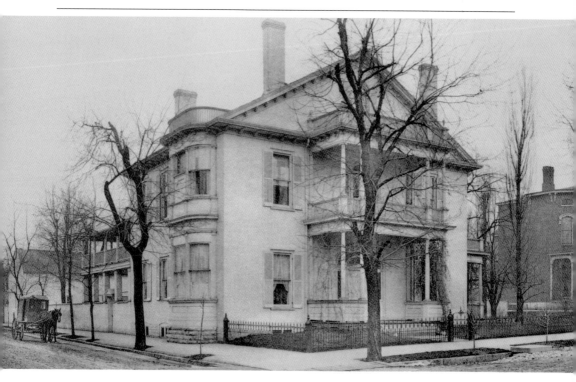

Some downtown Lexington neighborhoods seem to have had a change of fortune over the years. The old house on Mill Street was clearly quite modest compared to many of the larger mansions previously pictured. This section of Mill Street is filled with old brick houses, many now under the protection of the Bluegrass Trust for Historic Preservation, and the peaceful neighborhood is conveniently situated between the University of Kentucky campus and central Lexington. (Courtesy of the Bullock Photographic Collection, Transylvania University.)

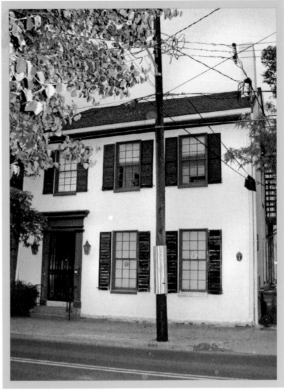

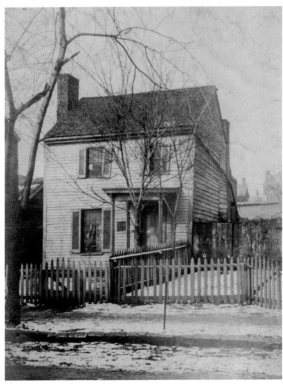

HOMES AND NEIGHBORHOODS

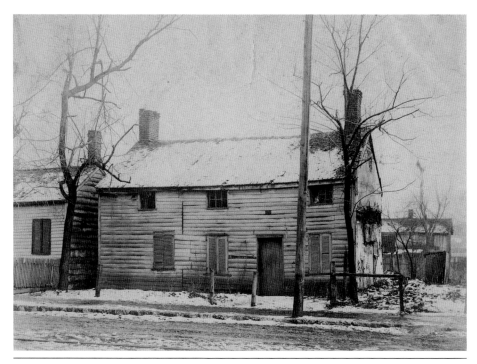

In contrast to the fortunes of Mill Street, other neighborhoods have remained relatively stagnant, with funds for renovation increasingly hard to come by. While some districts such as the nearby Elm Street have been completely transformed by urban renewal programs, others continue to be overlooked. Some houses along Jefferson Street may be well cared for and in good condition, but others lay vacant and derelict. (Courtesy of the Bullock Photographic Collection, Transylvania University.)

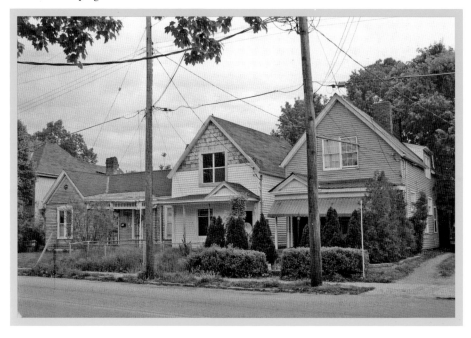

The Gothic Revival–style house on the 300-acre Ingelside Estate was built in 1852 as a wedding present from iron manufacturer Joseph Bruen to his daughter, Elizabeth. The 15-room mansion was often referred to as one of the castles of the Bluegrass. The home was demolished in the 1960s and replaced with a trailer park, which, in turn, has recently been razed for the planned construction of student housing. All that now remains is a small gatehouse building on South Broadway. (Courtesy of the Library of Congress, Prints and Photographs Division, Historic American Buildings Survey.)

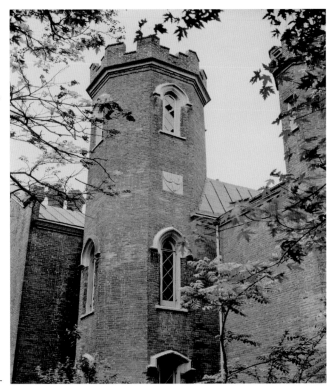

HOMES AND NEIGHBORHOODS

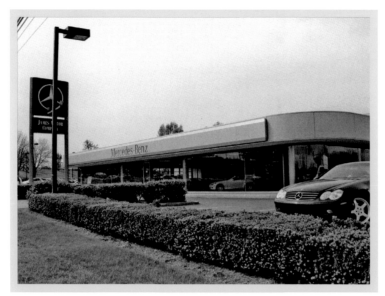

Ellerslie was built by one of Lexington's founders, Levi Todd, and was named for his ancestral home in Scotland. Built in 1787, it was one of the oldest brick houses in the state. The house was demolished in 1946–1947, and the surrounding land was an exclusive fishing club. The now-deserted Lexington Mall was constructed on part of the property in the 1970s, and a Mercedes car dealership stands on the site of the home. (Courtesy of the collection of Barton K. Bataille.)

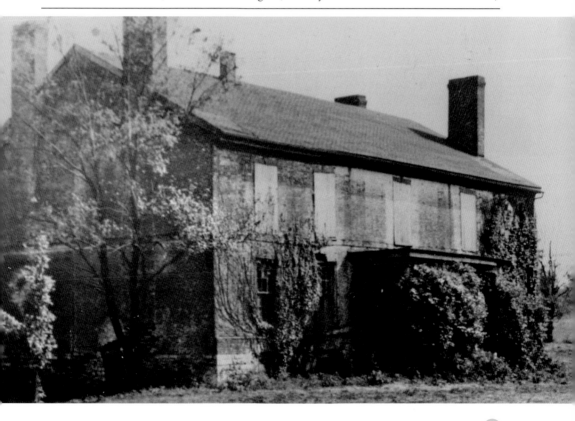

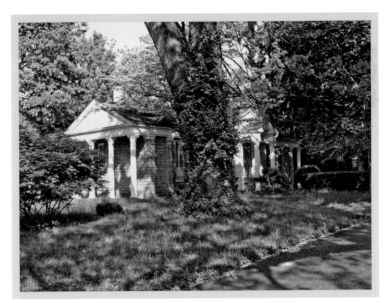

Built in 1851, the house known intriguingly as Botherum lies hidden away close to Versailles Road and High Street. The original owner, Madison Johnson, in addition to his reputation for eccentricity, was a graduate of Transylvania University, a lawyer, and a politician. Botherum is thought to be a monument to his wife, who died early in their marriage. The house was designed by John McMurtry. It is now privately owned and is part of a neighborhood that has been restored. (Courtesy of the Library of Congress, Prints and Photographs Division, Historic American Buildings Survey.)

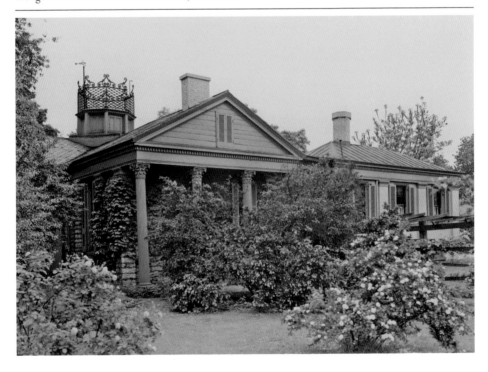

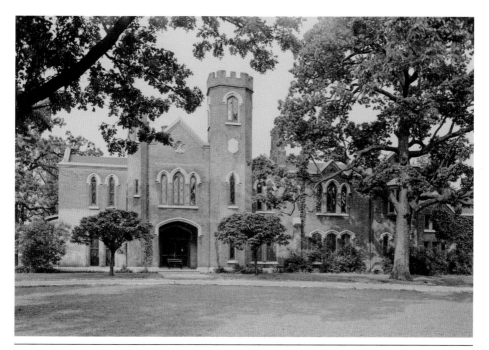

Loudoun House, like Ingelside, was built by John McMurtry for Francis and Julia Hunt. The house is an obvious visual contrast to the Greek Revival and Georgian architecture of other Lexington houses and is on the National Register of Historic Places. In the 1920s, the city bought the property and turned it into a park and community center. Since 1984, Loudon, as it is sometimes spelled, has been the home of the Lexington Art League. (Courtesy of the Library of Congress, Prints and Photographs Division, Historic American Buildings Survey.)

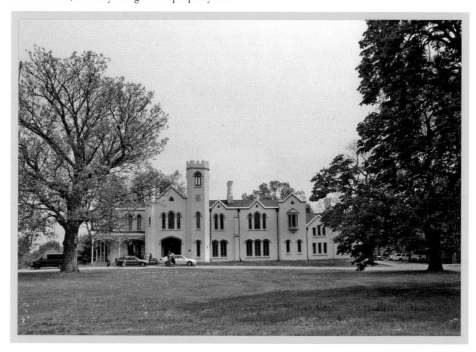

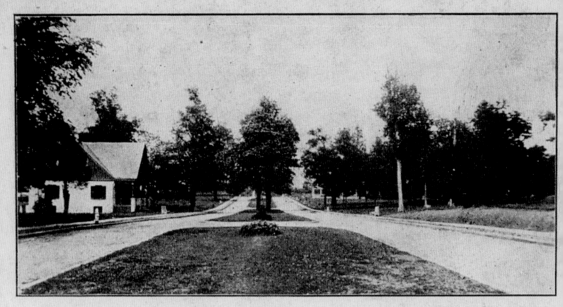

One of the Beauty Spots in Mentelle Park

Photo by Thos. A. Knight, Lexington; Ky

Victoria Charlotte Mentelle and her husband, Augustus, fled Paris and the French Revolution in 1792, settling first in Ohio and eventually in Lexington. Augustus became a banker and friend of Henry Clay, living opposite Clay's Ashland Estate on Richmond Road. Meanwhile, his wife opened an exclusive girls' boarding school attended by, among others, the young Mary Todd. The area was developed in 1906 and is now a quiet neighborhood close to downtown. (Courtesy of the Lexington History Museum.)

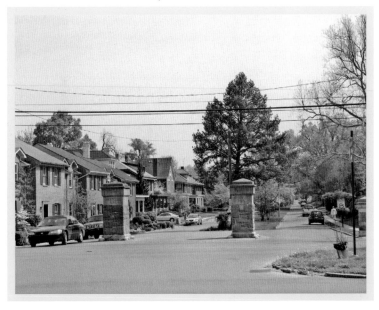

HOMES AND NEIGHBORHOODS

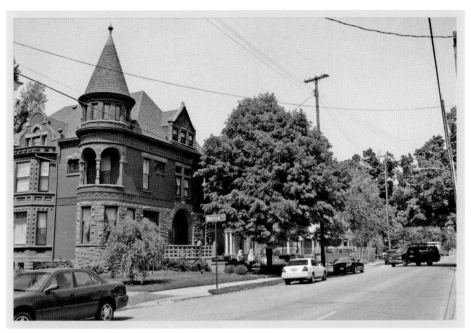

Once at the northernmost border of Lexington's city limits, Third Street is now a part of downtown. The section of the street shown here is lined with historic houses, some of which have fallen into disrepair while others have been carefully restored to their former glory. Alleyways along the block lead to charming hidden neighborhoods and gardens. Just one block away is the Transylvania University campus and Gratz Park. (Courtesy of the collection of Barton K. Bataille.)

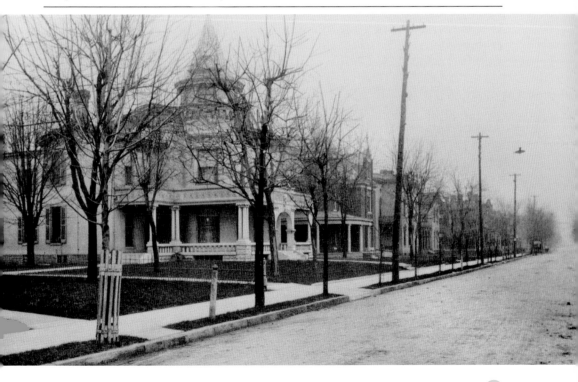

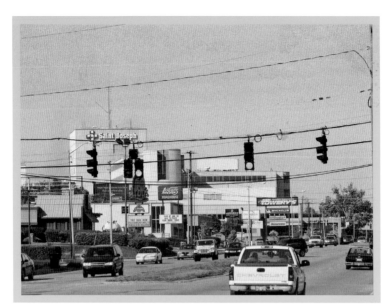

It is now hard to imagine that tiny toll houses and mills such as the one shown here were so far outside the city of Lexington around 100 years ago. Today this once-quiet part of the Harrodsburg Pike, near Mason Headley, is a bustling thoroughfare into downtown Lexington, with a huge medical complex, restaurants, offices, and other businesses. (Courtesy of the Lexington Public Library.)

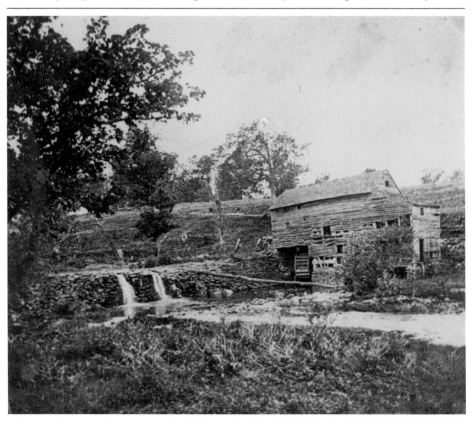

HOMES AND NEIGHBORHOODS

SCHOOLS, CHURCHES, AND HOSPITALS

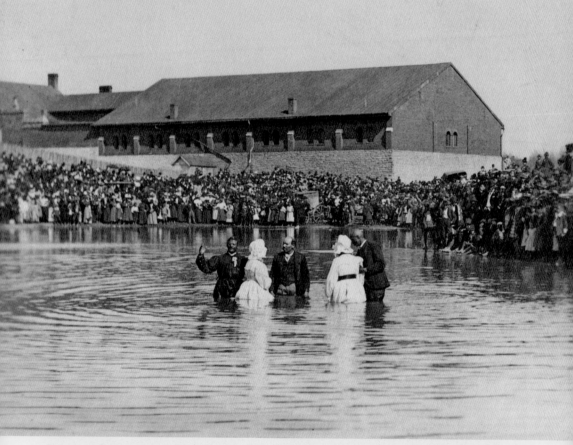

Visitors to Lexington cannot help but be struck by the large number of churches within the community. Here a baptism ceremony is held by the Historic Pleasant Grove Baptist Church at the workhouse pond on Bolivar Street. Pleasant Grove Church originated as the African Baptist Church, which was founded in 1790 and is the oldest African American congregation west of the Alleghenies. (Courtesy of the Bullock Photographic Collection, Transylvania University.)

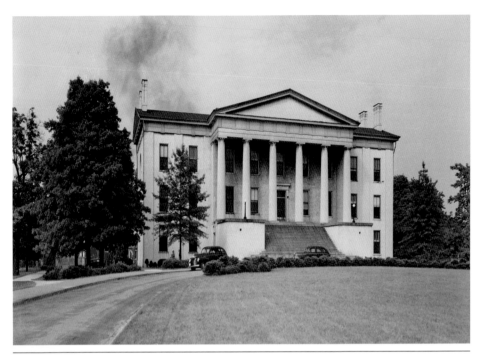

Designed by Gideon Shyrock, Morrison College was completed in 1933 as a replacement for the original building that was Transylvania University. A magnificently striking example of Greek Revival–style architecture, Morrison was named for benefactor Col. James Morrison. During the Civil War, it was used as an army hospital by both the Union and the Confederacy. The building underwent extensive renovation in the early 1960s. Morrison College, a National Historic Landmark, houses many of Transylvania's administration offices. (Courtesy of the Library of Congress, Prints and Photographs Division, Historic American Buildings Survey.)

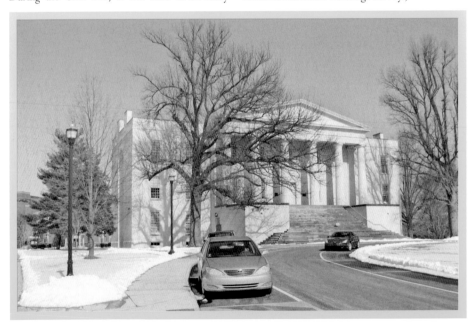

The University of Kentucky, once the State College of Kentucky, has expanded so much that this view has disappeared entirely. The lake was created in 1890, offering a wonderful spot for boating. Within 20 years, however, the lake was becoming a swamp, and it was drained and filled so that the campus could be developed. Today the college buildings in the distance are no longer visible, hidden behind a mass of newer buildings, including the Alumni Gymnasium, seen here. (Courtesy of the Art Work of the Blue Grass Region of Kentucky, Special Collections and Digital Programs, University of Kentucky.)

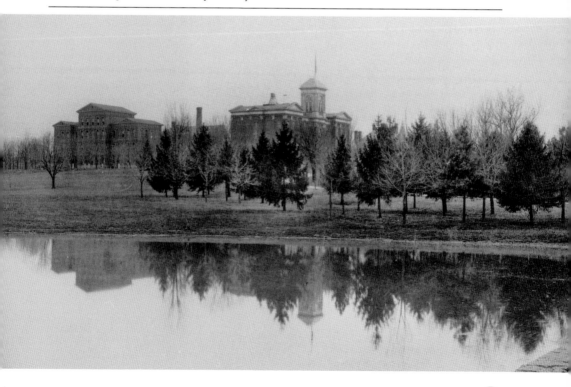

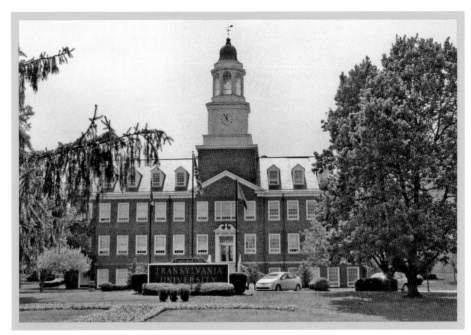

The College of the Bible was founded in Lexington in 1865 as one of several colleges that came under the umbrella of Kentucky University (now Transylvania University). In 1878, the college received its own charter, and in 1965, it celebrated its centennial by renaming itself the Lexington Theological Seminary. It moved to a new location in 1950, leaving the building shown in the photograph to be demolished in 1960. The Haupt Humanities Building, part of the Transylvania campus, now stands on the site. (Courtesy of the Art Work of the Blue Grass Region of Kentucky, Special Collections and Digital Programs, University of Kentucky.)

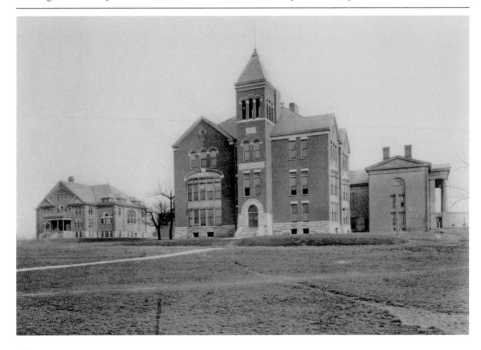

SCHOOLS, CHURCHES, AND HOSPITALS

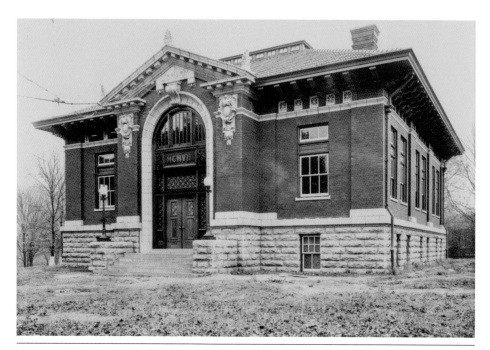

The first library at the University of Kentucky was the Carnegie Library, built in 1909 with Margaret King as its librarian. In 1948, it was renamed the King Library to honor her on her retirement. The growing number of volumes housed in the library called for expansion in the 1960s and 1970s, and in 1998, most of the library materials were moved to a new building. Today the King Library houses the special collections and several other offices. (Courtesy of the Library of Congress, Prints and Photographs Division, Historic American Buildings Survey.)

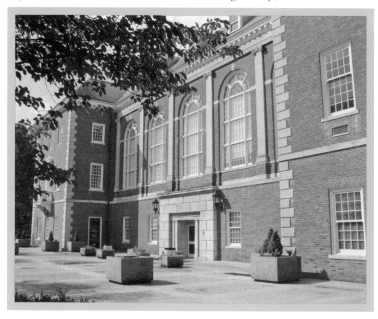

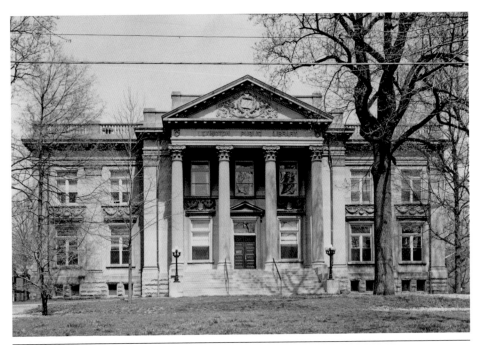

The Carnegie Center, formerly the Lexington Public Library, was built in 1903 at a cost of $75,000. Philanthropist Andrew Carnegie donated $60,000 of that total. Overlooking Gratz Park, it was designed by Herman Rowe in the Federal style. The public library moved to a new, larger location on Main Street in 1989, and this building was restored. It now offers literacy classes and programs in computing, languages, and writing. (Courtesy of the J. Winston Coleman Jr. Photographic Collection, Transylvania University Library.)

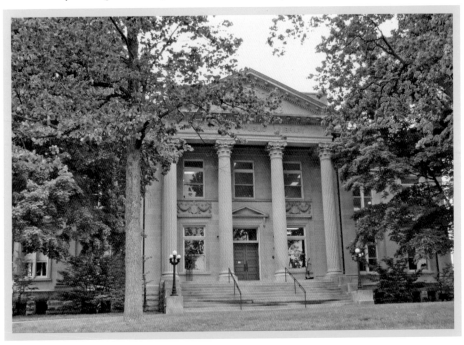

SCHOOLS, CHURCHES, AND HOSPITALS

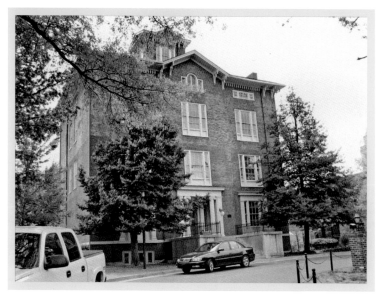

Lexington developed an early reputation for academic excellence with the presence of Transylvania University and several highly regarded schools. The Transylvania Female Institute, renamed the Sayre Female Institute in 1855, was founded by local banker David Sayre to provide girls with "an education of the widest range and highest order." Boys were admitted to its primary department in 1876, and the school became known simply as the Sayre School in 1942. Today it retains a strong presence in Lexington's academic community. (Courtesy of the Art Work of the Blue Grass Region of Kentucky, Special Collections and Digital Programs, University of Kentucky.)

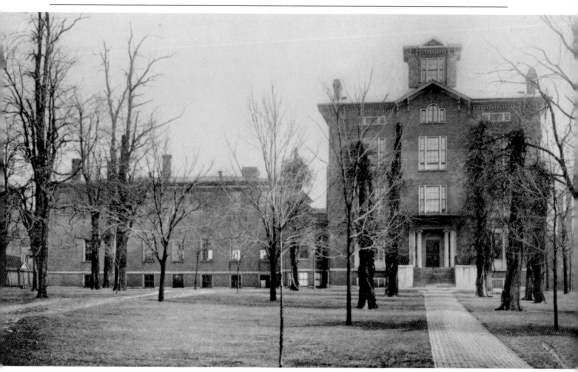

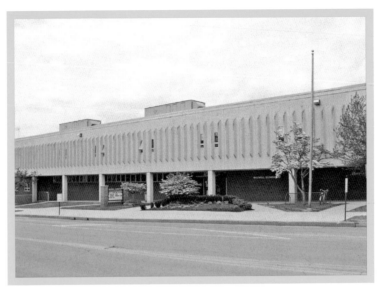

The tattered postcard shows Maxwell Elementary School, constructed in 1903 and named after John Maxwell, an early adventurer, one of Lexington's founders, and Fayette County's first coroner. The original building was razed in 1971 to be replaced by a new school, which still carries the same name. Maxwell Elementary is Fayette County's only Spanish Immersion School, with lessons taught in both English and Spanish. (Courtesy of the Lexington History Museum.)

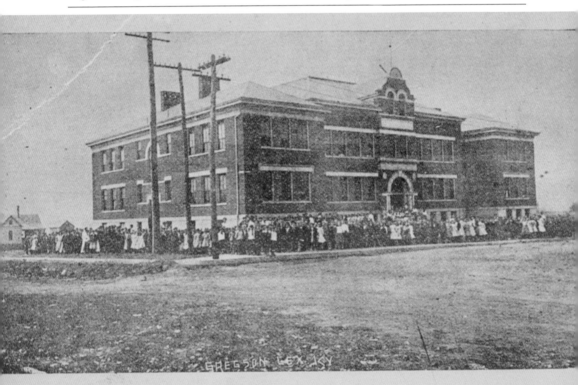

MAXWELL STREET PUBLIC SCHOOL, LEXINGTON. KY.

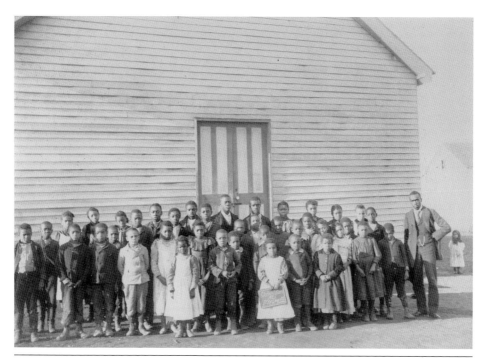

Cadentown was one of Kentucky's rural black hamlets at the beginning of the 20th century. Here students are shown outside the Cadentown School. In 1923, a Rosenwald school was built on the site, using funds provided by Julius Rosenwald, president of Sears, Roebuck, and Company. Cadentown is one of only two Rosenwald schools still standing in Fayette County. The school closed in 1946, but the building has recently undergone extensive renovation with the hope that it will become a museum. (Courtesy of the Fayette County Schools Photographic Collection, Special Collections and Digital Programs, University of Kentucky.)

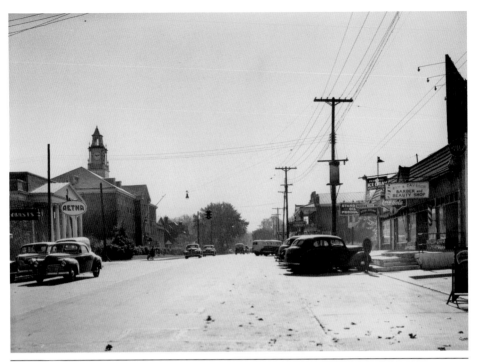

Henry Clay High School, the oldest public high school in Lexington that is still in operation, opened on Main Street in 1928. By the mid-20th century, it was considered one of the best schools in the South. In the 1970s, the school moved to a new facility, and the building seen on the left is the headquarters of the Fayette County Public Schools. (Courtesy of the Selected Images of Lexington [1930–1950], University of Kentucky Libraries.)

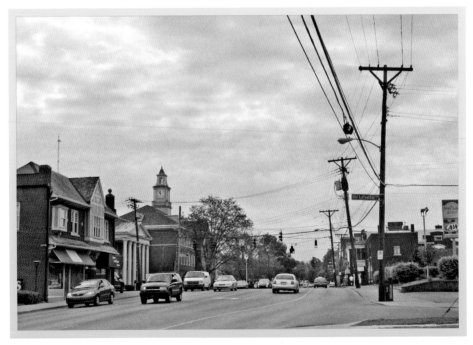

Picadome High School was built in 1928 but closed in 1939, when Lafayette High School opened in response to a need for larger facilities. When this 1934 photograph was taken, school started much later than expected due to an outbreak of polio. The school was torn down in 1976, and the Southside Center for Applied Technology is now on the site. (Courtesy of the Selected Images of Lexington [1930–1950], University of Kentucky Libraries.)

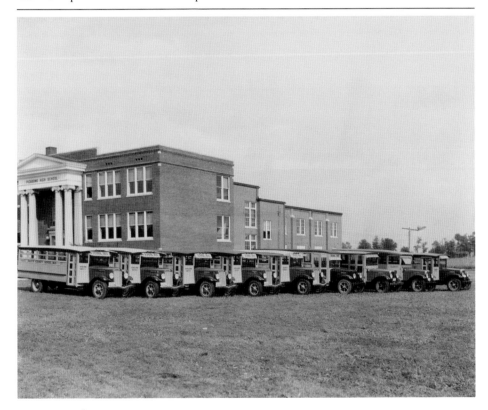

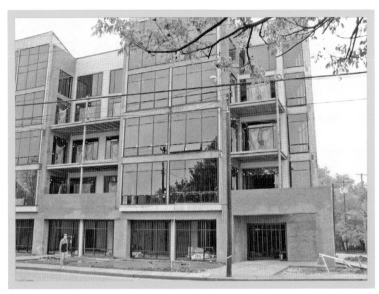

The Immanuel Church Tabernacle Baptist Church (renamed the Immanuel Baptist Church in 1924) was organized by members from Calvary Baptist Church in January 1909. First situated in a rented building on Upper Street, then on the corner of High Street and Woodland Avenue, the church eventually purchased some land on Tates Creek, where it relocated in 1962. A new congregation moved into the old building, and it continued to be used for worship until its recent demolition. (Courtesy of the Lexington History Museum.)

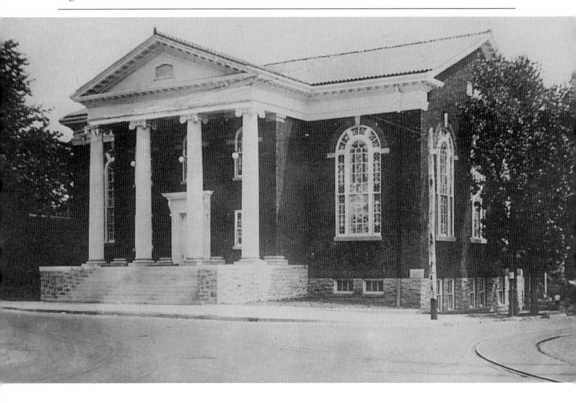

SCHOOLS, CHURCHES, AND HOSPITALS

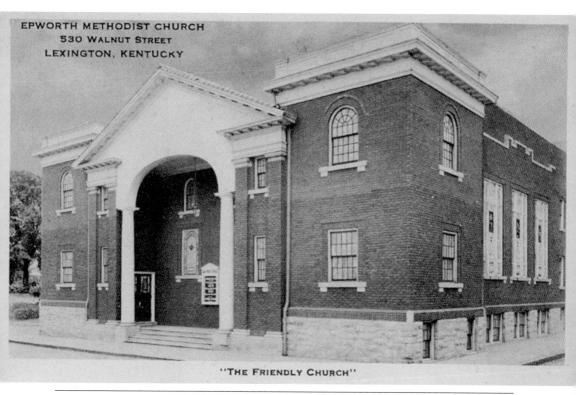

EPWORTH METHODIST CHURCH
530 WALNUT STREET
LEXINGTON, KENTUCKY

"THE FRIENDLY CHURCH"

The Epworth Methodist Church, built in 1918, is at the center of the Epworth Place Subdivision, which was developed in the late 19th century. Rand and Engman Avenues were the basis of the subdivision and displayed the difference in economic levels—the houses on Rand tended to be more decorous and prosperous, while those on Engman were more modest. The Greater Soul Deliverance Tabernacle is now housed within the church. (Courtesy of the Lexington History Museum.)

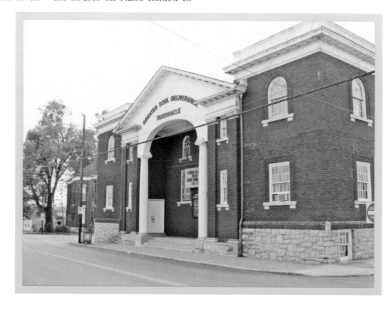

The Asbury Methodist Episcopal Church, nicknamed the Old Branch Church, was built about 1850 on Water Street. The African American congregation had organized in 1830, and by the 1880s, they had moved to a new building on High and Mill Streets, leaving this building vacant. In 1963, Asbury Methodist and Gunn Tabernacle rejoined as the Wesley Methodist Church. Meanwhile, the building shown here was demolished, and the LexTran bus depot now spans the entire block. (Courtesy of the collection of Barton K. Bataille.)

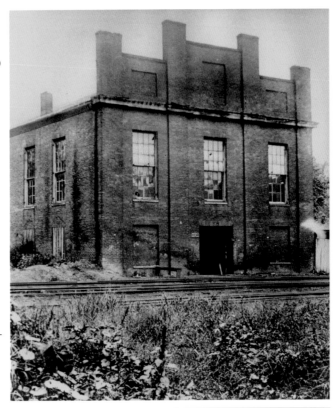

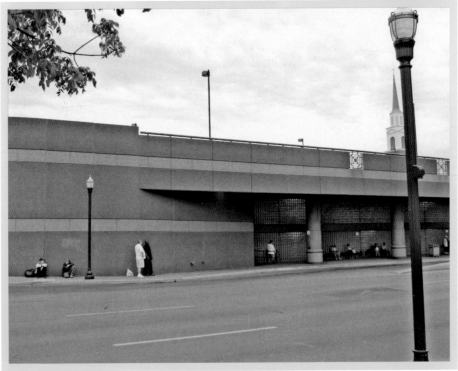

SCHOOLS, CHURCHES, AND HOSPITALS

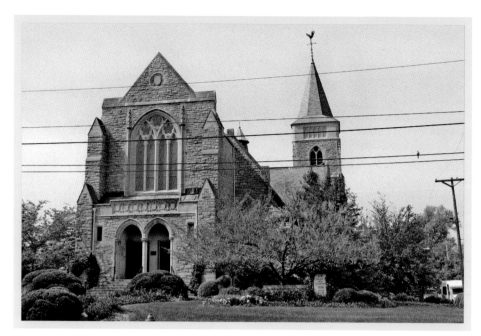

The Market Street Church was dedicated in 1815 with James McChord as its pastor. In 1818, it joined the Presbyterian denomination. In 1823, the church organized what may have been Lexington's first Sunday school, and in 1828, it became the Second Presbyterian Church. The original building was destroyed by fire in 1917, and the current church was dedicated in 1924. No longer in the suburbs, Second Presbyterian is now located in the downtown area and has undergone a great deal of expansion. (Courtesy of the Lexington History Museum.)

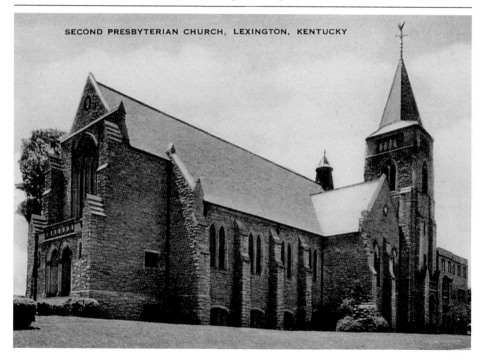

SECOND PRESBYTERIAN CHURCH, LEXINGTON, KENTUCKY

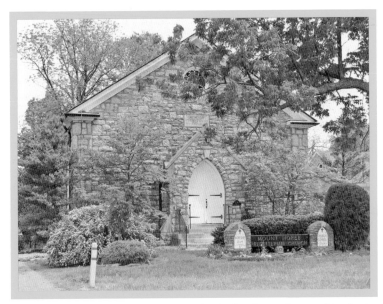

The charming Mount Horeb Presbyterian Church on Iron Works Pike was built in 1828. The congregation had been organized in 1827 at the home of Mary Cabell Breckinridge, the widow of U.S. senator and Thomas Jefferson's attorney general John Breckinridge. The original brick church was destroyed by fire in 1925. The replacement building, which is still in use today, was dedicated in 1926. (Courtesy of the Art Work of the Blue Grass Region of Kentucky, Special Collections and Digital Programs, University of Kentucky.)

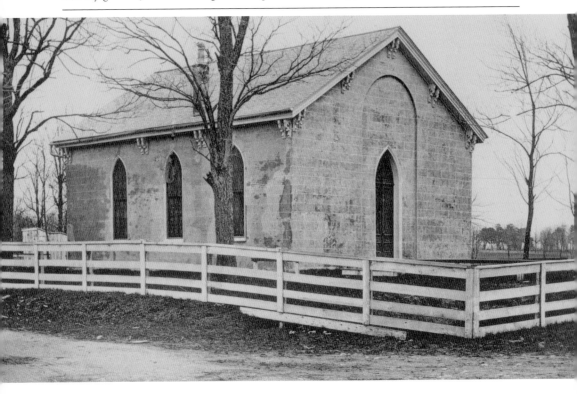

SCHOOLS, CHURCHES, AND HOSPITALS

This church community was organized in 1816 by a group who had been meeting in a private home for about nine years. First called the Hill Street Christian Church, the congregation later became the Main Street Christian Church. In 1894, the church moved to its present location and changed the name again. The Central Christian Church continues today. Incidentally, the church's current site is the only known site of a settler being killed by Native Americans within view of the original fort (1781). (Courtesy of the Art Work of the Blue Grass Region of Kentucky, Special Collections and Digital Programs, University of Kentucky.)

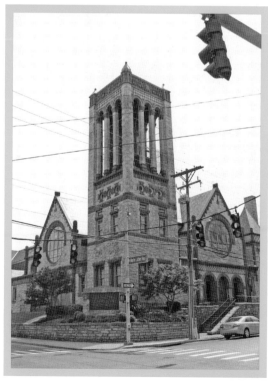

The first burial at the Lexington Cemetery took place in October 1849 when Robert Boyd, a victim of the cholera epidemic, was moved from the Episcopal Cemetery. The 40-acre tract of land had previously been known as Boswell's Woods and was used for hunting. In 1890, the gateway to the grounds was replaced with the stone chapel and building seen here. The structure is still in use today. (Courtesy of the Art Work of the Blue Grass Region of Kentucky, Special Collections and Digital Programs, University of Kentucky.)

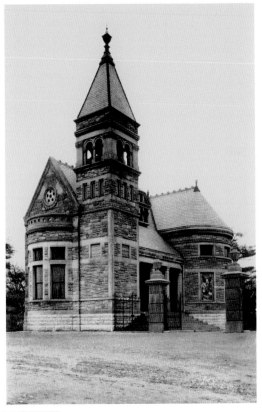

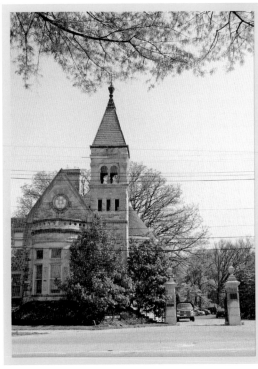

SCHOOLS, CHURCHES, AND HOSPITALS

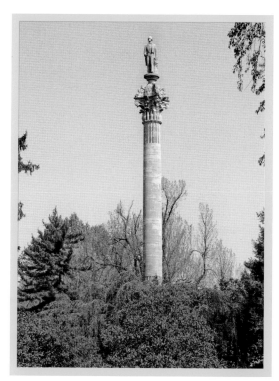

The towering monument to Henry Clay in the Lexington Cemetery overlooks what was once the entire city. Just one day after Clay's death in 1852, a committee gathered to raise funds, and by 1861, the monument was complete. The bodies of both Clay and his wife, Lucretia, rest in the vault at the base of the tower. In the 1970s, the limestone monument underwent extensive restoration to repair damage caused by decades of exposure to the elements. (Courtesy of the Lexington History Museum.)

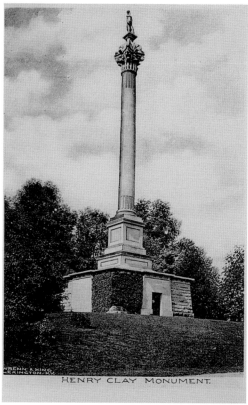

HENRY CLAY MONUMENT.

SCHOOLS, CHURCHES, AND HOSPITALS

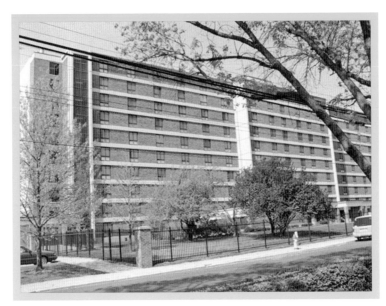

The city's first hospital, St. Joseph's, was opened by the Sisters of Charity of Nazareth, Kentucky, and was moved to West Second Street just a few months after it opened in 1877. In 1959, it moved again to its current location on Harrodsburg Road. The former hospital was demolished in 1966 and is now the site of the Ballard Griffith Towers, a public housing community for seniors. (Courtesy of the J. Winston Coleman Jr. Photographic Collection, Transylvania University Library.)

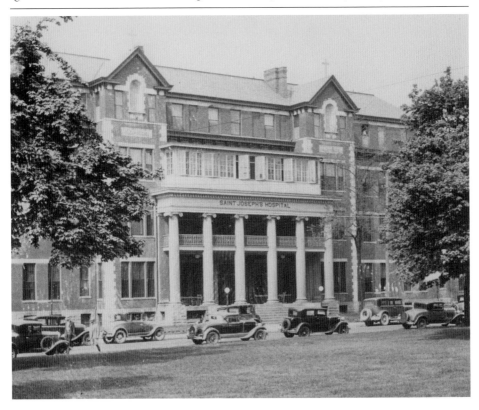

SCHOOLS, CHURCHES, AND HOSPITALS

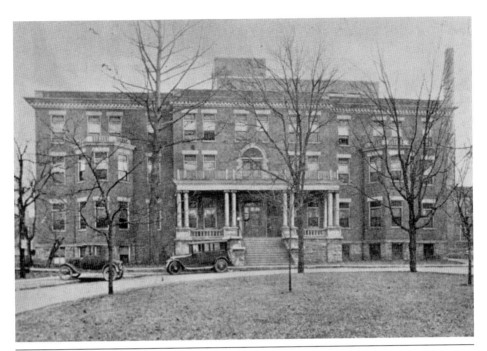

The Good Samaritan Hospital began as the Protestant Infirmary on East Short Street. In 1899, it changed its name to Good Samaritan, and in 1905, the hospital trustees bought the property on Limestone where it is still located. The new building was dedicated in 1907. The Southern Methodist Church took over management of the hospital in 1925, but by the early 21st century, it was facing financial difficulties. In 2007, the University of Kentucky bought the hospital. (Courtesy of the J. Winston Coleman Jr. Photographic Collection, Transylvania University Library.)

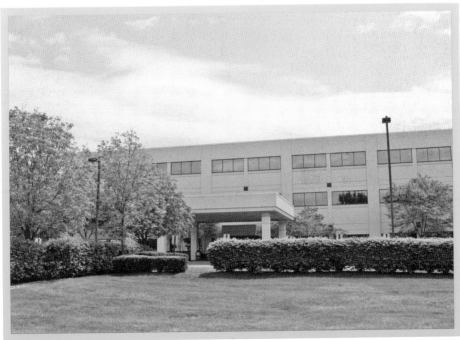

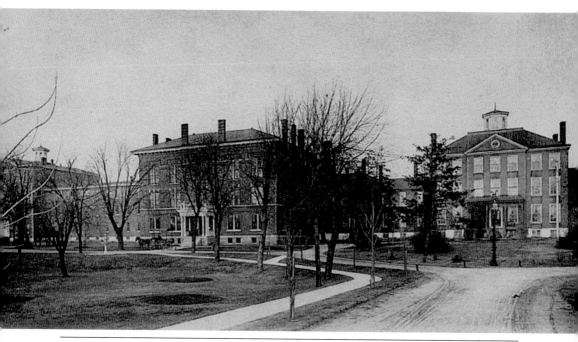

The campaign for erecting the Kentucky Lunatic Asylum began in 1816. The facility was completed in 1822, and the first patient was admitted in 1824. The second asylum built in the United States, Eastern State—as the asylum is now known—played host to the Lunatics Ball, quite the social event in late-19th-century Lexington. Today plans are underway to relocate it to a new facility, and the original buildings will be taken over by a local college. (Courtesy of the Lexington History Museum.)

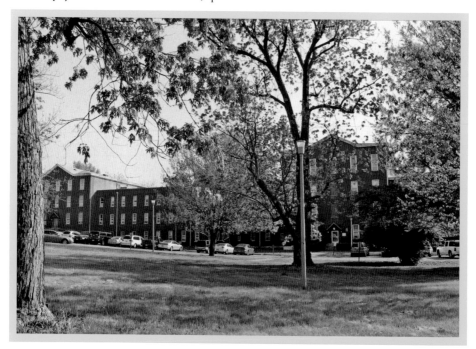

SCHOOLS, CHURCHES, AND HOSPITALS

LEXINGTON'S DISAPPEARING LEGACY

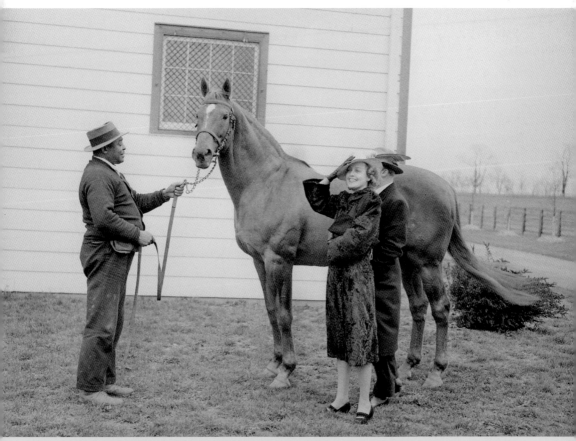

What would the Bluegrass state be without horses? In Lexington, racehorses have achieved the status of celebrities, and none more so than Man O' War. People traveled from far and wide to see him at his home on Faraway Farm. This picture shows actress Jeanette McDonald meeting the champion. (Courtesy of the Collection on Lafayette Studios, University of Kentucky Archives.)

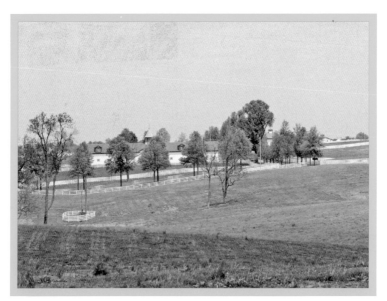

Established in 1924 by businessman William Monroe Wright, Calumet Farm was named after Monroe's baking powder company. It originally thrived in the world of Standardbreds, but by the 1930s, the farm had moved on to Thoroughbreds and soon boasted a string of champions, including Citation. After a few decades of ups and downs in the racing world, the farm was auctioned in 1992 and rescued from bankruptcy. Today Calumet thrives again and is easily recognized as one descends into Blue Grass Airport. (Courtesy of the Selected Images of Lexington [1930–1950], University of Kentucky Libraries.)

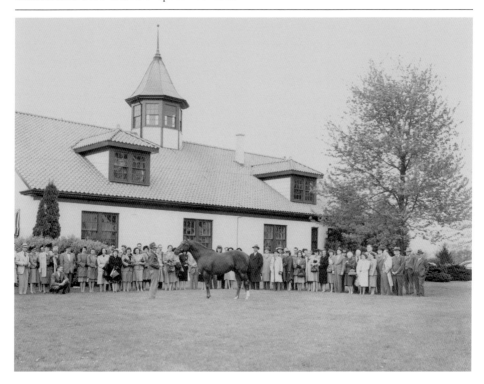

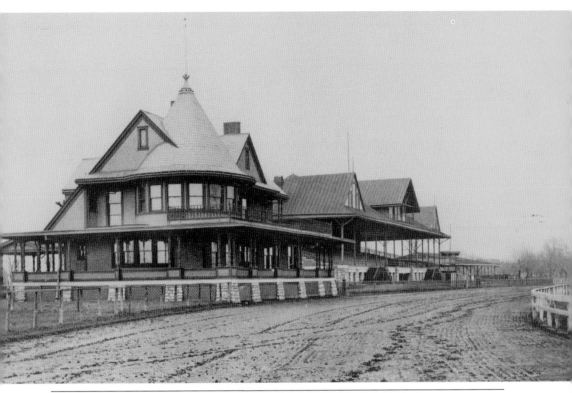

The Kentucky Association Racetrack, also known as "Chittlin' Switch," was established in 1826 and was sold to the Kentucky Jockey Club in 1918. The last race took place in 1933. Races moved out to Keeneland, and the old track was demolished just a few years later, being replaced by Bluegrass-Aspendale, Lexington's first public housing complex. Those homes have been torn down, and a new neighborhood of private and public housing is being built. (Courtesy of the Art Work of the Blue Grass Region of Kentucky, Special Collections and Digital Programs, University of Kentucky.)

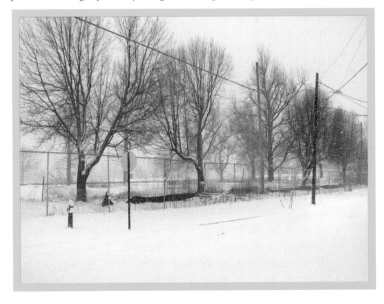

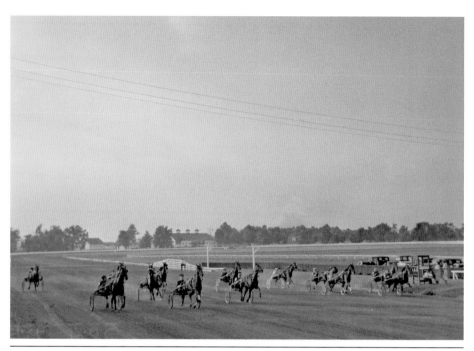

Red Mile Racetrack was once a fairground on the remote edge of the city. On September 28, 1875, the Kentucky Trotting Horse Breeders Association held the first day of harness racing there, reportedly with slim attendance and little advertising. Since then, the summer races at the Red Mile have become much more popular, and the second oldest harness track in the world hosts races, sales, and numerous other events. (Courtesy of the Selected Images of Lexington [1930–1950], University of Kentucky Libraries.)

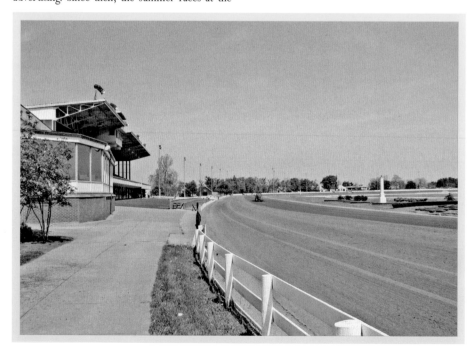

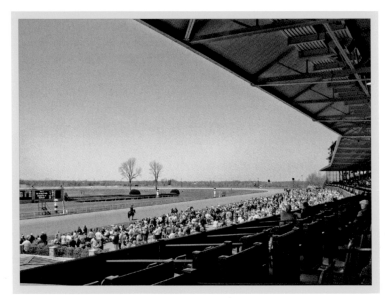

The first meet at Keeneland was in the fall of 1936, and two years later, the first horse sale took place, with the highest price paid being $3,500. Today the racing continues, with meets in both April and October. Meanwhile, the sales regularly set new records, with horses now being sold for several million dollars. The clubhouse and grandstand have been rebuilt and expanded to accommodate the 11,000-strong crowd who attend each day of races. (Courtesy of the Lexington History Museum.)

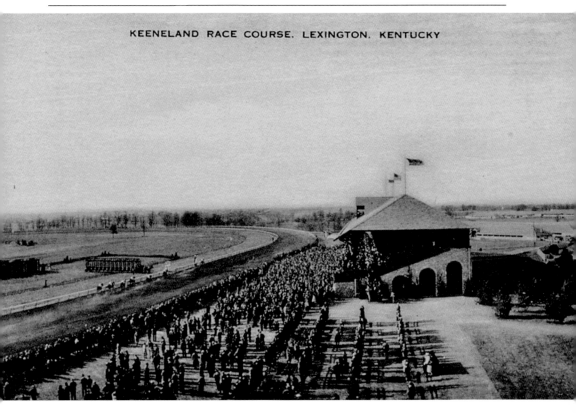

KEENELAND RACE COURSE. LEXINGTON. KENTUCKY

LEXINGTON'S DISAPPEARING LEGACY

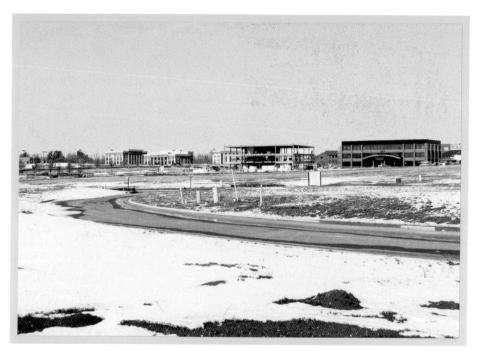

Beaumont Farm, once owned by the prominent Headley family, covered hundreds of acres in south Lexington. A mansion was built in 1924, complete with tennis courts, a pool, and a formal garden. Over the years, the house has been demolished, and much of the land has been redeveloped into residential subdivisions, including Gardenside, Palomar, and Beaumont, although several descendants still own land in the area. Shown here is some of the recent office-space construction at Beaumont. (Courtesy of the Art Work of the Blue Grass Region of Kentucky, Special Collections and Digital Programs, University of Kentucky.)

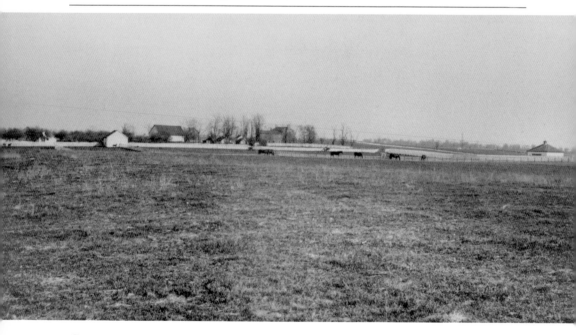

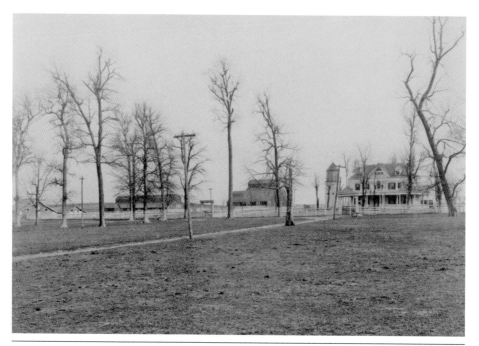

Meadowthorpe, now a charming neighborhood of tree-lined avenues, was once a horse farm owned by local bookmaker W. H. Cheppu. Later it was the site of Lexington's first airfield and was visited by Charles Lindbergh, who declared it too small and barely missed the trees when taking off. The neighborhood located there today was built in the late 1940s. (Courtesy of the Art Work of the Blue Grass Region of Kentucky, Special Collections and Digital Programs, University of Kentucky.)

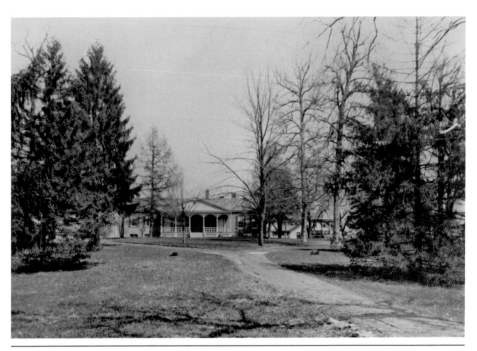

Patchen Wilkes Farm on Winchester Road was owned by millionairess Rita Hernandez de Alba Acosta, the wife of William Earl Dodge Stokes, known locally as "the Horse Lady." In 1897, to celebrate the building of a new barn, Mrs. Stokes held a ball for approximately 200 African American guests and out-of-town friends. Reportedly, the highlight of the event was a cakewalk competition. Today the farmhouse and some land remain, but a new housing subdivision has been built on part of the estate. (Courtesy of the Art Work of the Blue Grass Region of Kentucky, Special Collections and Digital Programs, University of Kentucky.)

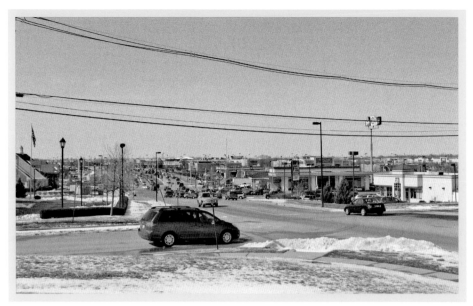

In less than a decade, no part of Lexington has changed as dramatically as the Hamburg Place. Once an impressive thoroughbred farm and racetrack owned by the Madden family, much of the land has been sold and redeveloped for commercial and residential purposes. Viewing the area today, one would never guess that, just a few years ago, green pastures lay where shopping malls now sprawl, and congestion is a constant problem. (Courtesy of the James Edwin "Ed" Weddle Photographic Collection, Special Collections and Digital Programs, University of Kentucky.)

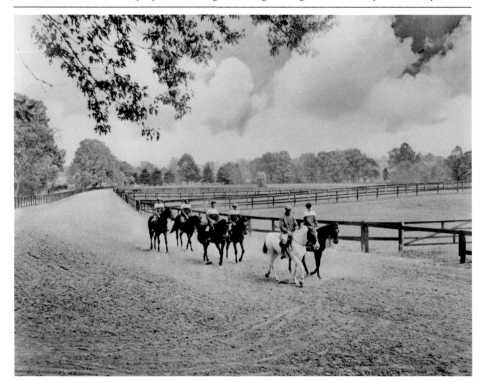

LEXINGTON'S DISAPPEARING LEGACY

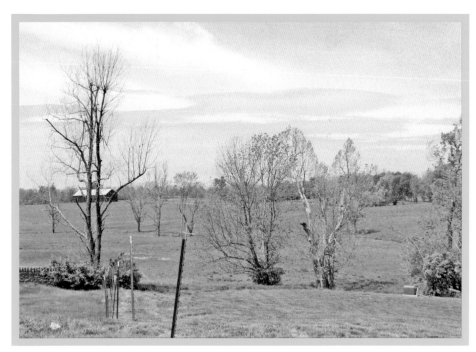

Where Thoroughbreds once had their first riding lesson, luxury houses and condominiums are being built. Ironically, the expensive new residences overlook a Super Wal-Mart store. Next to the mass of shops and offices on the former Hamburg Farm, some green space remains, providing a buffer between the past and the present, the new construction and the original farm house still occupied by the Madden family. (Courtesy of the Lexington History Museum.)

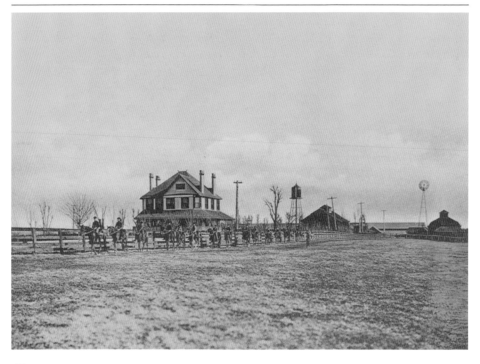

LEXINGTON'S DISAPPEARING LEGACY

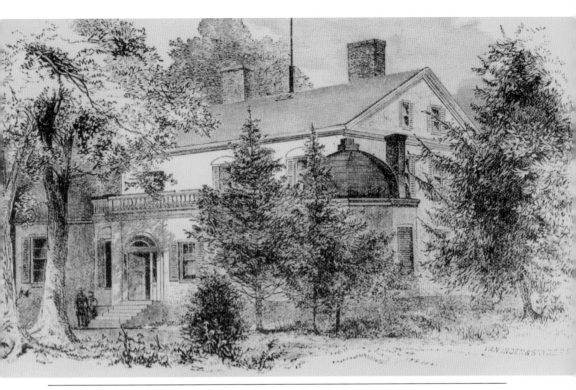

Woodlands Farm was once owned by Anne Brown Clay Erwin, daughter of Henry Clay. In 1866, it was purchased by Kentucky University, and the main house was used as the Horticultural Department's building. Eventually, Kentucky University would become the University of Kentucky, and by 1900, the estate had become a park with a small lake and a concert hall. The house is no longer standing, but Woodland Park remains a beautiful downtown spot. (Courtesy of the Louis Edward Nollau F Series Photographic Print Collection, *c.* 1885–1966, University of Kentucky Libraries, Special Collections and Archives, University Archives and Records Program.)

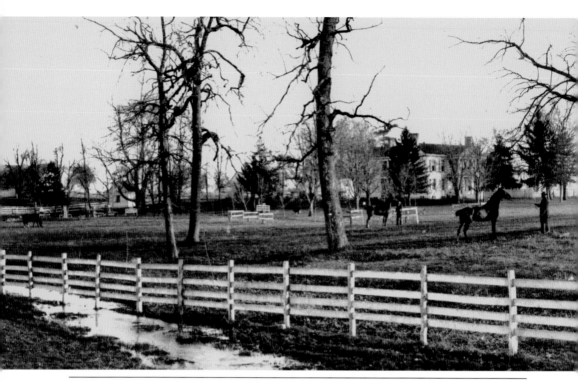

Like many horse farms in the Bluegrass, as Lexington grew and land became more sought after for residential and commercial development, Springhurst Farm was eventually sold off and redeveloped. In the late 19th century, owner C. L. Railey was renowned for his high-quality Saddlebred horses. Today the area is comprised of subdivisions and a shopping center. All that remains of the name is a hotel. (Courtesy of the Art Work of the Blue Grass Region of Kentucky, Special Collections and Digital Programs, University of Kentucky.)

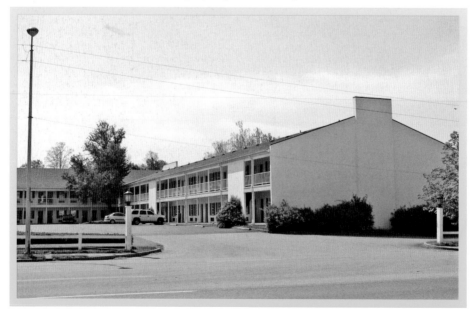

LEXINGTON'S DISAPPEARING LEGACY

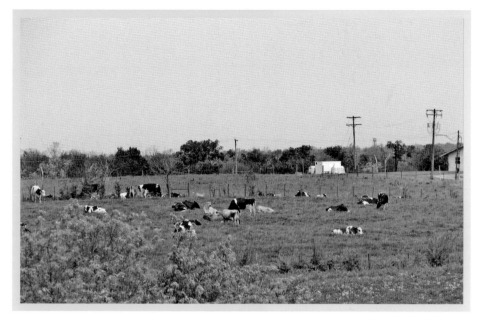

Lest one think that farming in Fayette County has always been restricted to horses and tobacco, Lexington once had a great deal of land used for cattle farming, particularly during the 1930s and 1940s. This image shows local farmers proudly displaying their Jersey cows at a cattle auction at Forward Farm on Georgetown Pike in 1934. Today most of this land has been lost to the sprawl of urban development, but one can still find cows along Georgetown Road. (Courtesy of the Selected Images of Lexington [1930–1950], Audio-Visual Archives, University of Kentucky Libraries, Lexington.)

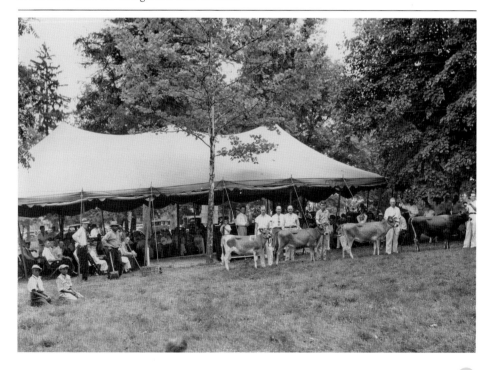

Across America, People are Discovering Something Wonderful. *Their Heritage.*

Arcadia Publishing is the leading local history publisher in the United States. With more than 3,000 titles in print and hundreds of new titles released every year, Arcadia has extensive specialized experience chronicling the history of communities and celebrating America's hidden stories, bringing to life the people, places, and events from the past. To discover the history of other communities across the nation, please visit:

www.arcadiapublishing.com

Customized search tools allow you to find regional history books about the town where you grew up, the cities where your friends and family live, the town where your parents met, or even that retirement spot you've been dreaming about.